NIKON® SPEEDLIGHT®
HANDBOOK

FLASH TECHNIQUES
FOR DIGITAL
PHOTOGRAPHERS

STEPHANIE ZETTL

AMHERST MEDIA, INC. ■ BUFFALO, NY

DEDICATION

This book is dedicated to Peter Zettl, my husband, best friend, and business partner. We really do have the greatest adventures. I love you. And to David A. Williams—knowing you has not only made me a better photographer, it has made me a better person.

Published by:
Amherst Media, Inc.
P.O. Box 586
Buffalo, N.Y. 14226
Fax: 716-874-4508
www.AmherstMedia.com

Publisher: Craig Alesse
Senior Editor/Production Manager: Michelle Perkins
Assistant Editor: Barbara A. Lynch-Johnt
Editorial Assistance from: Carey A. Miller, Sally Jarzab, John S. Loder
Business Manager: Adam Richards
Marketing, Sales, and Promotion Manager: Kate Neaverth
Warehouse and Fulfillment Manager: Roger Singo

ISBN-13: 978-1-60895-451-3
Library of Congress Control Number: 2011942802
Printed in The United States of America.
10 9 8 7 6 5 4 3 2

Check out Amherst Media's blogs at: http://portrait-photographer.blogspot.com/
http://weddingphotographer-amherstmedia.blogspot.com/

TABLE OF CONTENTS

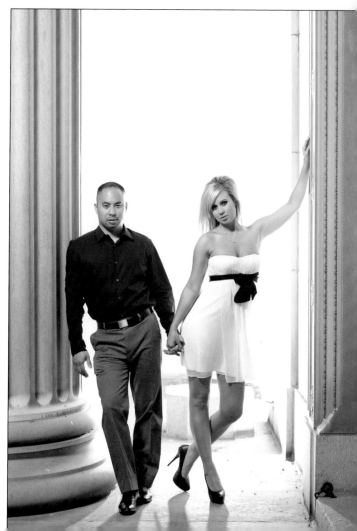

ABOUT THE AUTHOR

PHOTO BY JOHN FEDELE.

Stephanie Zettl is a photographer from St. Louis, Missouri who specializes in photographing people. She got her start as a freelance newspaper photographer. She enjoys photographing people and their relationship to the world. In 2003 she started her own business specializing in documentary-style wedding and portrait photography. Her husband, Peter, later joined her in the business as a photographer and business partner. Together they have developed it into one of the top wedding studios in St. Louis, winning many awards both locally and internationally.

Stephanie is a respected lecturer and mentor who enjoys watching new photographers improve their skills. Education is important to Stephanie and she believes that photographers should invest in themselves by studying both the technical and creative sides of photography.

"My passion lies not in the act of pressing a shutter button, but in telling the story of the person in front of my lens," she says. "Knowing my technical skills so that they become second nature to me allows me to better connect with my subjects and share their stories with much more clarity and strength."

More of Stephanie's work can be found on her website at www.zettlphoto.com.

ACKNOWLEDGEMENTS

There are a lot of people I need to thank for the success I have achieved in my life. I would have never been able to accomplish so much without the love, support, and help of my family, friends, and mentors. My sincerest thanks for all you have done.

There are a few people who have helped me with my adventures as a photographer and in the writing of my first book. I would like to specifically thank them here.

To Neil van Niekerk—Your friendship, help, support, and sometimes less-than-gentle nudges to keep focused on writing the book have been very much appreciated. Thank you!

To Ray Kersting—You will always be lovingly known as the little pebble that started the avalanche of good things.

To Alecia Hoyt and Jeannie Worley—For the reminder to dream big, because dreams do come true.

To Phil Braden, Lindsay Silverman, and Matt Kachevas—For taking the time and energy to explain in detail some very fascinating technical information.

To those who have helped me see the light, shape the light, and create the light: Chuck Arlund, Greg Gibson, Cliff Mautner, Jerry Ghionis, and John Michael Cooper.

To Storey Wilkins—Our conversations about life and art have greatly influenced my work.

To all my wonderful clients who invited me into their lives to document it.

To my fabulous models who patiently sat for photos in this book: Briley Jones; Feleg Abraha; Mallory Brown; Millissa Rodgers; Ray Prevost; Hadassa and Brian Brooks; Lindsay Crawford; Keith and Alison Lee; Tammy Howell; Diana Pitts; Meredith and Brandon Thiergart; Madeleine Hepperman; Danielle Ronco; Jody Wynen; and Jenny Battenberg.

To Chrissy Stojan, D'Shannon Llewellyn, Holly Speakes, and Cindy McCalla for all your help on hair and makeup for my models.

To those who assisted on photo shoots for the book: Jen Norris, Pam Bredenkamp, and Benjamin Trevor Bremmeier.

And finally to Bruce Schneider, who took a chance on me in my senior year of high school and let me be a student newspaper photographer when I didn't even know what an f-stop was. His kindness and belief in me started me on a journey that has taken me to places I could have never imaged. I wish he were alive so that I could share this with him.

FOREWORD

BY NEIL VAN NIEKERK

WWW.NEILVN.COM/TANGENTS

"Oh, you're so technical in your photography" is a comment that just rankles me. As if it isn't possible to know what you're doing *and* be creative. As if knowledge negates inspiration.

Amidst all the either/or discussions (whether it is better to have technical command of a subject or better to be a creative person) is a simple truth: we need both. The best photographers, by far and large, have a clear grasp of the technical aspects of photography as well as a creative energy for what they do. These two things are not mutually exclusive.

With a solid understanding of how our equipment works, and of the fundamentals of light and lighting, we will be much better equipped to deal with challenging situations. We can also more readily respond to a subject on an intuitive level because we don't have to get stuck on settings and dials.

Photographers need a near-instinctive understanding of the essentials. We need to know how to handle our cameras—and how the choices we make about shutter speed, aperture, ISO, and focal length each affect our final images. We need to just know these things on a level where we can access it without thought. Only when we understand how everything interrelates, only when our camera controls and settings intuitively fall under our fingers, are we able to respond instinctively and capture those moments effortlessly and with success.

Of all these things we need to understand, the use of flash is often most mystifying to the new photographer. There is no escaping the fact that insight into how our flashguns work—what they are capable of and how best to apply flash photography techniques—will impact our photography if we have it all down pat. We need to know these things.

In your hands you hold a book written by a photographer who is accomplished, skilled, and creative. Stephanie knows her stuff! In this book, she brings together the technical aspects of Speedlights and the related gear, instructions on how to shoot with the equipment, and techniques for achieving great images. These are the things we need to know. Enjoy—and make it your own!

INTRODUCTION

To flash, or not to flash? That is the question facing many photographers. Many people don't think about using their flash until the quantity of light is too low for a proper exposure. But the truth of the matter is, your Speedlight is a powerful tool that can improve not only the *quantity* but also the *quality* of light in your photographs. Properly directing and shaping the light can add mood, shape, texture, and color to make your photographs more dynamic and visually interesting. In general, we should be using our flashes long before the quantity of light demands it.

Nikon has named their Speedlight system the Creative Lighting System (CLS) because it gives us the tools and features to tackle almost any lighting needs and situations. The system not only gives us many options for on-camera flash, but it also allows us to control multiple lights wirelessly, with full through-the-lens (TTL) metering. Nikon calls this their Advanced Wireless Lighting (AWL) system and it opens up a world of possibilities for creating great photographs.

This book will help you understand how to use your flashes, how to modify the light from your flashes, and how to make your subject look good in different lighting situations.

Before we begin taking advantage of the CLS, however, it is a good idea to understand the basic characteristics of lighting—the quality and diffusion of light, the direction of the light, and the color of the light. Each of these components plays an important role in making both appealing and professional-looking images. We'll also discuss aperture, shutter speed, and ISO and how they relate to getting good exposures.

For many of you, the following information might be a refresher. For those of you newer to photography or working with Speedlights, I encourage you to carefully study the following information; it will give you a solid basis for working with your Speedlights and knowing when to use them. In addition, read the photo captions. In them, you'll find a fair amount of discussion about the photographs and the techniques applied.

I believe that it is extremely important to master the technical skills of photography. When we are comfortable with our technical skills, we are free to focus on the creative side of photography and fully accomplish our artistic vision. I hope that this book will give you the knowledge to be comfortable with your Speedlights and also inspire you to create images beyond what you thought was possible.

1. UNDERSTANDING LIGHT AND EXPOSURE

THE CHARACTERISTICS OF LIGHTING

When you mention flash, many people think of the harsh, cold light of direct, on-camera flash. It's the reason that some people say that flash looks unnatural or unflattering and shy away from using it. However, it is possible to get good-looking flash photographs by using the flash to improve the existing light or to overpower poor available light. Taking great flash photographs just

In this photo, the well-defined shadows caused by the harsh sunlight produced a pretty pattern on the wall and nicely framed Briley. I made sure to pose my model properly so that there were no unflattering shadows on her face. (f/3.2, $\frac{1}{4000}$ second, ISO 160)

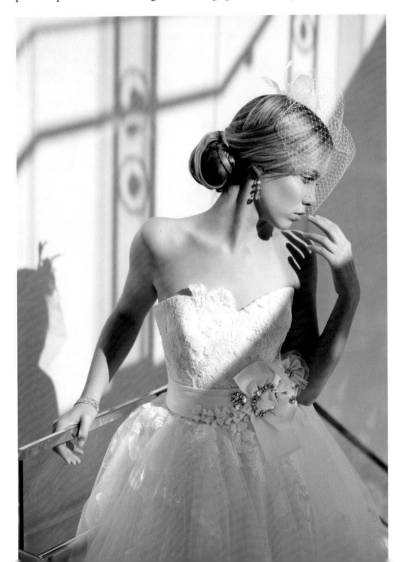

Besides making Lindsay squint, the harsh sunlight in this photo has caused unflattering shadows on her face. (f/2.8, $^1/_{3200}$ second, ISO 200)

By moving Lindsay into softer light I was able to create a much more flattering portrait of her. (f/4, $^1/_{250}$ second, ISO 200)

requires an understanding of the characteristics of light and the techniques needed to enhance them with your flash.

Quality of Light: Hard *vs.* Soft Light. You'll notice a huge improvement in your photography when you start looking more at the quality of light instead of the just the quantity of light. The quality of light is usually defined as hard or soft lighting. You can recognize hard or soft light based on the type of shadows in the photo. Looking at the shadows in a photograph is just as important as looking at the lighting. The shadows tell you a lot about the quality and the direction of the light.

Hard light is the type of light found on a bright, sunny day. It comes from a single source point of light (like the sun) and is very directional. It is characterized by well-defined shadows and a quick transition from light to shadow. You can also get hard light with direct, undiffused flash. Used properly, hard light can create interesting shapes and texture with the shadows. It can show detail,

render very saturated colors, and communicate specific moods in a photograph—like strength and power.

Used improperly, hard light can be considered unflattering. It can create weird, distracting shadows and bad cross lighting. It can also cause too great a difference in exposure from your highlights to your shadows, which makes it difficult to properly expose for all the tones in your image and still retain detail in your shadows and highlights. In situations like this, you can use your Speedlight to illuminate some of the shadow areas and reduce the contrast.

Soft light is smooth, even light, like you find on a cloudy day. It comes from multiple directions and is characterized by undefined shadows. The softness of the light depends on the distance of the light source to the subject. The closer the light source, the softer the light. It also depends on the size of the light source; the larger the light source, the softer the light.

To create soft light with a Speedlight, the light needs to be diffused through a translucent material or bounced off a reflective surface (which could be anything from a wall to a photographic umbrella). Both techniques increase the size of the light source. In much the same way, clouds act as a giant softbox diffuser to the sun. They increase the relative size of the light source by diffusing and scattering the light beams. The result is soft light where the shadows have less defined edges.

Used properly, soft lighting can be very flattering for portraits. It can minimize wrinkles, scars, and other skin imperfections. It generally gives a very even exposure over the entire scene,

While the exposure is correct, the diffused light on Jenny's face is unflattering. Its diffused, non-directional nature makes her eye sockets dark and the scene lacks visual interest. (f/2.0, $^1/_{200}$ second, ISO 400)

In this photo, I kept Jenny in the shade but moved her to a position where the sun was reflecting off a nearby wall. Notice the light in her eyes and the soft, warm light on her face. (f/2.5, $^1/_{640}$ second, ISO 400)

eliminating harsh shadows. It can add a calm, peaceful mood to the photograph.

Used improperly, lighting that is too soft or too diffused and non-directional can lack visual interest from an absence of texture, color, and shape. The scene can look dull and dreary.

Direction of the Light. Though we live in a three-dimensional world, the photographs we create are two-dimensional. The only way to show dimension and depth in our photos is by the interplay of light and shadow. Once again, we need to pay attention to the shadows. We need to get in the mind-set of knowing where our shadows will fall depending on the direction of the light.

Color Temperature. The color of light can vary greatly from warm (orange) to cool (blue). Daylight ranges from the warm glow of morning light, to the bright and mostly neutral colored midday sun, to the cool tones of open shade or twilight. Artificial

POINTS TO REMEMBER

We use flash to:
1. Supplement the existing light
2. Reduce the range and contrast from the brightest point to the darkest point in a scene
3. Create a more dynamic and visually pleasing image

We characterize lighting by its:
1. Quality
2. Direction
3. Color

DAYLIGHT COLOR TEMPERATURES

Clear blue sky	8000–27,000K
Misty daylight	7200–8500K
Overcast	6500–7200K
Direct sun, blue sky	5700–6500K
Midday sun (9:00am–3:00pm)	5400–5700K
Sun at noon	5000–5400K
Early morning or late afternoon	4900–5600K
Sunrise or sunset	2000–3000K

ARTIFICIAL LIGHT COLOR TEMPERATURES

Fluorescent, daylight-balanced	6500K
Electronic flash	6200–6800K
Fluorescent, cool white	4300K
Photoflood	3400K
Tungsten-halogen	3200K
Fluorescent, warm white	3000K
General-purpose lamps (200–500W)	2900K
Household lamps (40–150W)	2500–2900K
Candle flame	2000K

TOP—Daylight has a crisp, clean feel.

MIDDLE—Fluorescent light can have a cold, inhospitable feel.

BOTTOM—The warm glow of tungsten light gives an intimate feel.

light also shows a wide range of color—tungsten light is warm, often orange, while fluorescent bulbs tend to have a green cast to them.

We quantify the color of light by measuring its color temperature in degrees Kelvin (K). The warmer (more orange) the light, the lower the color temperature. Tungsten lights, for example, register close to 2800K. The cooler (more blue) the light, the higher the color temperature. The color temperature in open shade is often rated at 7000K. A neutral color temperature is often referred to as daylight-balanced or 5500K.

The color of the light is important. It can greatly affect the mood of your photographs. Warm light will have a peaceful, soft feel to it. Blue light tends to give a cooler, more mysterious feel. The green coloration of fluorescent lights can have a industrial feel. And while the neutral light of daylight-balanced flash may be very clean and "correct," it can lack some of the mood that lighting with a different color temperature will have. While we should always be very aware of the "right" color temperature, we also want to make sure we are not correcting our photographs to the point of making the color sterile.

EXPOSURE

Before we start adding more light to a scene with our Nikon Speedlights, it's good to have a solid understanding of how exposure works and how to properly set it and change it. While shooting in RAW and using editing software like Adobe Photoshop and Lightroom

can give you a little latitude for correcting exposure error, you should make every effort to get it right in camera.

A good definition of a "correct" exposure is simply the exposure needed to achieve the effect the photographer wanted. (This is an important detail to remember later when we discuss choosing our settings when working with flash.) In more technical terms, a proper exposure is achieved when there is sufficient detail in both the shadows and the highlights of an image. If a photograph is overexposed, there will be loss of detail in the highlights; they will be mostly white and washed out. If a photograph is underexposed, the danger is a lack of detail in the shadows and blacks.

The three components of exposure are aperture, shutter speed, and ISO. Understanding how these work individually and in harmony will give you the ability to make specific decisions about the look of your photographs and allow you to be more creative.

Aperture. The aperture is the opening in the lens through which light travels to the image sensor. By using a diaphragm, the opening in the lens can change, allowing you to let in more or less light. Apertures are described by f-numbers, or more commonly as f-stops. The f-stop is determined by dividing the focal length of the lens by the diameter of the aperture.

F-stop = focal length/aperture diameter

APERTURE F/2.8

APERTURE F/5.6

The f-stops follow a set sequence of numbers so that by moving up or down the progression of f-stops you are halving or doubling the image brightness.

As you can see in the diagram, f/1 is the largest aperture and lets in the most light, while f/22 is the smallest opening and lets in the least amount of light. While it might seem contrary to say 1 is larger than 22, f/1 is always referred to as a larger aperture because it is a wider opening; f/22 has a smaller opening and is referred to as a smaller f-stop. You will also often hear photographers talk about "stopping down" or "opening up." Stopping down means you are moving to a smaller aperture opening—like from f/4 to

STANDARD PROGRESSION OF F-STOPS

f/1 f/1.4 f/2 f/2.8 f/4 f/5.6 f/8 f/11 f/16 f/22

wider aperture　　　　　　　　　　　　　　　　　　　　　　　*smaller aperture*

(allows in more light)　　　　　　　　　　　　　　　　　　　*(allows in less light)*

APERTURE F/22

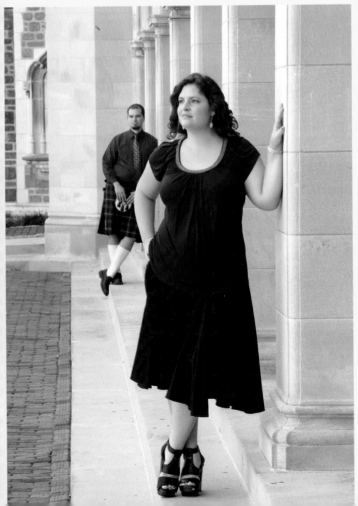

In this series of photos of Alecia and Tim, you can see the effect that different apertures have on a photograph. Tim goes from being a blurry object in the background (at f/2.8) to being fully recognizable (at f/22), just by changing the aperture.

STANDARD PROGRESSION OF SHUTTER SPEEDS (IN SECONDS)

1 $\frac{1}{2}$ $\frac{1}{4}$ $\frac{1}{8}$ $\frac{1}{15}$ $\frac{1}{30}$ $\frac{1}{60}$ $\frac{1}{135}$ $\frac{1}{250}$ $\frac{1}{500}$ $\frac{1}{1000}$ $\frac{1}{2000}$

slower shutter speed *faster shutter speed*
(more motion blur) *(little or no motion blur)*

f/16. If you are moving from f/22 to f/5.6 you are "opening up," or increasing the aperture size to let in more light.

Besides the amount of light that it lets through the lens, the aperture also controls the depth of field. This is the distance between the nearest and farthest objects in a photograph that are in focus. A larger f-stop (f/2.8, for example) will let in more light, but it will also have a narrower depth of field. This tends to isolate a subject by keeping it in focus and letting everything else fall out of focus. A smaller f/stop (like f/22) will let in less light but give you greater depth of field, showing almost everything in focus.

Understanding this allows you more creative control of your photographs. After all, it is better to choose your aperture for a specific reason (such as "I want to isolate my subject" or "I need to have everyone in this large group in focus") than to choose it just to control the amount of light entering your camera. In many cases, photographers will choose their aperture based on the depth of field they want in an image and then adjust their shutter speed and ISO setting to create the correct exposure. However, if you are trying to capture motion in a certain way, aperture might not be the most important factor in your settings. For that, you would base your other settings off your shutter speed.

Shutter Speed. The shutter speed is used to describe how long the camera's shutter remains

BELOW—In this series of photos of Jenny, I placed my camera on a tripod and had her walk across the scene at the same pace in each photograph. At a shutter speed of $\frac{1}{3}$ second, Jenny is just a blur. The faster shutter speeds were able to freeze her movement so there was no motion blur.

SHUTTER SPEED $\frac{1}{3}$ SECOND

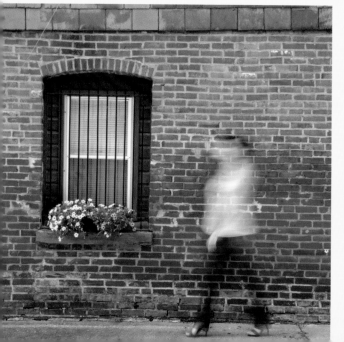

SHUTTER SPEED $\frac{1}{30}$ SECOND

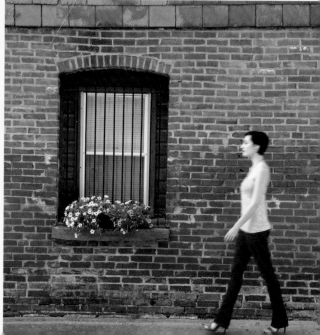

open to allow light to reach the film or sensor. It is also known as the exposure time. Longer exposure times (like 1 second) are referred to as "slow" shutter speeds; shorter exposure times are called "fast."

Shutter speeds are measured in seconds or fractions of seconds. The smaller the fraction of time, the less light that reaches the sensor. Similar to apertures, the standardized scale for shutter speeds halves or doubles the amount of light let into the camera as you increase or decrease your shutter speed.

Besides having an effect on the exposure, the shutter speed controls how movement appears in the photograph. A fast shutter speed will freeze the action. For fast-moving action photos, such as when shooting sports images, most photographers will work at $\frac{1}{250}$ second or faster. Slower shutter speeds will blur all movement, including movement from the photographer who is holding the camera. A slow shutter speed will show blur just from small movements of your hands, even if you are photographing inanimate objects.

Shutter speed also plays a role when determining your maximum flash sync speed, needed for proper exposure and to maximize the power of your flash. (We'll discuss this in the next section.)

ISO. ISO is the measurement of the film or image sensor's sensitivity to light. (Technically, saying that changing a DSLR's ISO is changing the sensor's sensitivity to light is wrong, since the sensitivity on a digital sensor is fixed. However, for exposure purposes, it is the best way to think about it.) The lower the ISO, the less sensitive the film or sensor and the more light that is needed to create a proper exposure. Greater ISO numbers mean a greater sensitivity to light.

Like shutter speeds and apertures, moving along the scale of ISO speeds will halve or double your exposure with each full step.

STANDARD PROGRESSION OF ISOs

ISO 100 ISO 200 ISO 400ISO 800 ISO 1600ISO 3200ISO 6400

less noise, more detail *more noise, less detail*

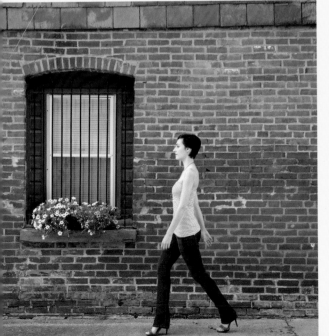

SHUTTER SPEED ⅟₁₂₅ SECOND

SHUTTER SPEED ⅟₅₀₀ SECOND

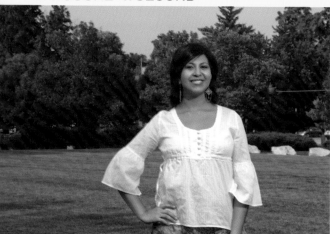

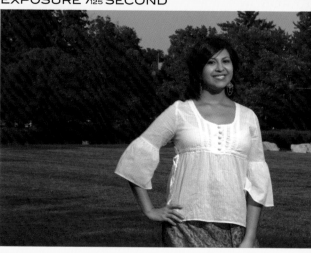

It is important to note that as you increase your ISO, you will also increase the amount of grain (for film capture) or noise (for digital capture) in your image. Noise is characterized as the colored specks often seen in the shadow parts of an image. Generally, you should use the lowest ISO possible for the situation you are shooting in to minimize the amount of noise in your photographs. Having the correct exposure, achieved by using the aperture, shutter speed, and ISO together, will generally result in a lower amount of noise.

EQUIVALENT EXPOSURES

For any set amount of light, you will find multiple combinations of aperture, shutter speed, and ISO that will each create a correct exposure. The main thing to remember is that as you move in one direction on your aperture scale, you will need to move in the opposite direction for your shutter speed to maintain the same exposure. A correct exposure at $1/60$ second and f/5.6 will also be a correct exposure at $1/125$ second (lets in one stop less light) and f/4 (lets in one stop more light). It's all a balancing act.

Once you have that figured out, you can choose your shutter speed and aperture based on your vision. Choose your shutter speed based on if you want to stop motion (fast shutter speeds) or blur it (slow shutter speeds). Choose your aperture for the amount of depth of field you want. Select larger apertures for shallow depth of field and smaller apertures for greater depth of field.

While you will normally not adjust your ISO much, there are times when it will come in handy. In low-light situations, you may want to use it to maintain shutter speeds that allow you to hand-hold your camera. It can also be useful to increase your ISO when you want to increase your depth of field without reducing your shutter speed. In certain specialties, such as wedding photography, you are going to be in a variety of light situations throughout the day. Don't be afraid to use ISO 100 in the midday sun, and slowly change your ISO throughout the day to end up at higher ISOs for a candlelit reception. (If you are able to get a proper exposure, most professional cameras can produce nice results even at ISO 6400.) Changing your ISO will allow you to have more control over your shutter speed and aperture.

EXPOSURE 1/250 SECOND

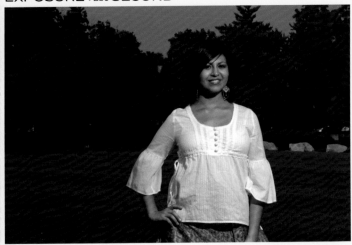

Your shutter speed can be used to cut down on ambient light. In these images of Hadassa, I was able to make the background darker by simply changing the shutter speed from $^1/_{60}$ second to $^1/_{125}$ second to $^1/_{250}$ second. The flash exposure on her stayed the same because the aperture of f/16 and the manual flash power setting of $^1/_2$ power did not change.

FLASH EXPOSURE

Manual flash exposure is affected directly by aperture, distance, ISO, and power output. One of the first things that photographers should learn when working in manual flash is that the aperture controls the flash exposure, while the shutter speed controls the ambient light exposure.

Adjusting the Shutter Speed. There will be times when you want your ambient light to be more prominent in the photos and other times when you want the flash to be the main (or only)

In these photos of Keith and Alison, the Speedlight output was set to $^1/_{32}$ power (manual flash) and the aperture was set to f/8. By changing the shutter speed from $^1/_{250}$ second to $^1/_{30}$ second to $^1/_4$ second, I was able to let in more ambient light without changing the flash exposure.

EXPOSURE 1/250 SECOND

EXPOSURE 1/30 SECOND

EXPOSURE 1/4 SECOND

source of light. You can adjust your shutter speed to achieve this. Reducing (making slower) your shutter speed will allow more ambient light to register; increasing (making faster) your shutter speed will allow less ambient light to register.

You will want to use slower shutter speeds in low-light situation to collect more ambient light and show a sense of depth and location in a photograph. You can use higher shutter speeds in brightly lit scenes to create more dramatic photographs that make your subject stand out by darkening the surroundings while still properly illuminating the subject.

So why doesn't the shutter speed have an impact on the manual flash exposure? It all has to do with how quickly the burst of flash happens. The flash's burst of light is extremely short—in fact, the slowest flash burst for the Nikon SB-900 is $\frac{1}{880}$ second at full power. At reduced flash output, it's even faster—$\frac{1}{38500}$ second for manual flash at $\frac{1}{128}$ power output. This burst is so much shorter than the maximum flash sync speed (see chapter 3) that the shutter speed of the camera has no effect on it.

SO WHY DOESN'T THE SHUTTER SPEED HAVE AN IMPACT ON THE MANUAL FLASH EXPOSURE?

Adjusting the Aperture. The aperture setting, on the other hand, determines the amount of light entering the lens. The larger the aperture, the more light the lens will let in. The smaller the aperture, the less light the lens will let in. This can be a useful control if you have your manual flash set to full power and are underexposed—or if you are at the minimum manual flash output and are still overexposed. If you cannot change your flash's distance to the subject, you can adjust your aperture to get the proper exposure.

Changing Your ISO Setting. We talked earlier about how proper exposure is determined by aperture, shutter speed, and ISO. So how does ISO relate to flash exposure? ISO affects both the ambient light and the flash equally. Increasing your ISO increases the amount of light collected by the sensor, whether from ambient or flash.

A Note on TTL Flash. The above information holds true when working with manual flash. It changes a bit when you are working with TTL flash. In i-TTL mode, the flash takes into con-

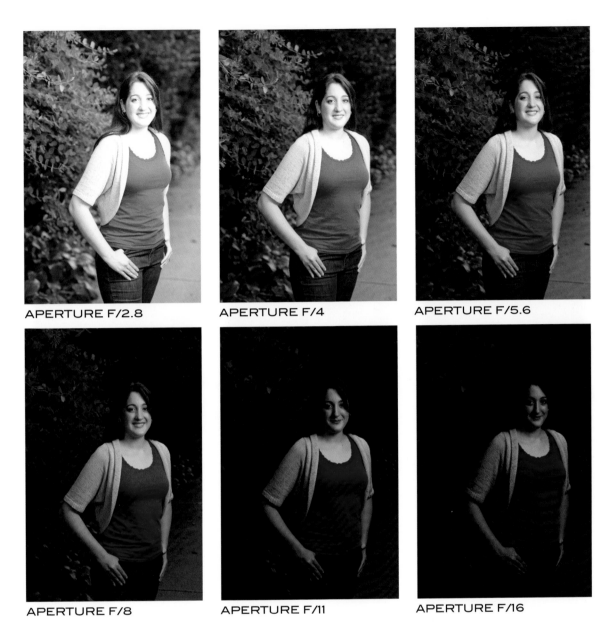

APERTURE F/2.8

APERTURE F/4

APERTURE F/5.6

APERTURE F/8

APERTURE F/11

APERTURE F/16

For these photos of Meredith, I fitted a softbox with a flash set to manual ($^1/_{32}$ power) and set my shutter speed to $^1/_{160}$ second. The shutter speed and the power output remained constant for all the images. Notice how moving from f/2.8 to f/16 made the photo go from overexposed to underexposed, proving that the aperture setting affects the manual flash exposure.

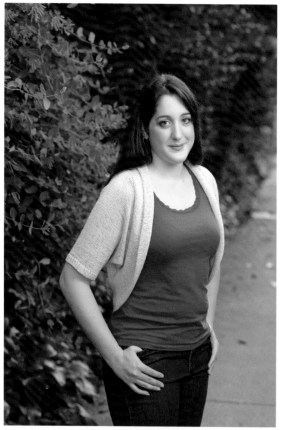

APERTURE F/4

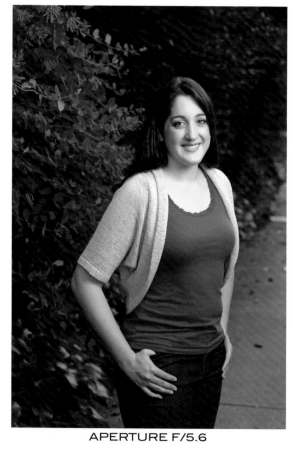

APERTURE F/5.6

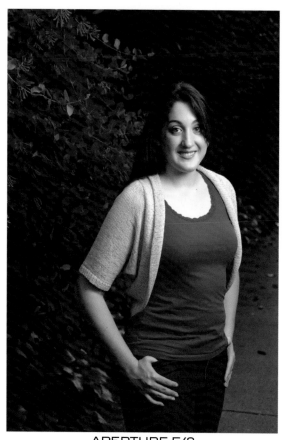

APERTURE F/8

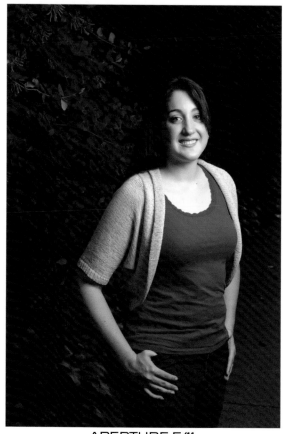

APERTURE F/11

sideration any changes to your ISO and aperture, then adjusts the flash output accordingly. This means that in i-TTL mode you can use your aperture, ISO, and shutter speed to control the ambient light. In the image sequence on page 23, you saw how adjusting the aperture when shooting with manual flash led to underexposing my subject. In the facing-page examples shot with i-TTL, I was able to adjust my aperture and the flash output adjusted itself automatically.

METERING

There are several different ways to meter for exposure. You can use a hand-held light meter or your camera's built-in light meter. You can opt to check the camera's histogram. You can also use the camera's blinking highlights display and LCD.

Hand-Held Light Meters. Hand-held light meters measure how much light is falling on your subject, also known as the "incident" light. Like any meter, these devices provide a reading designed to expose a subject as middle gray. However, because they measure the light *before* it hits the subject, the exposure calculation is not influenced by whether the subject of the photograph is light or dark. This makes them a great resource when you are working with manual flash. They give quick, accurate readings based on the output of your flash.

Built-In Light Meters. Your camera has a built-in light meter that measures the light reflected by a scene or subject. Like hand-

FACING PAGE—With TTL flash, the flash takes into consideration any change in aperture and ISO and makes adjustments to the flash output. As long as you stay within the power range of your flash, you can change your aperture and the flash will automatically adjust to provide the correct exposure on your subject. These images were shot at $^{1}/_{160}$ second and ISO 400.

DIFFERENT IMAGES, DIFFERENT HISTOGRAMS

While these images are both properly exposed, their histograms are very different.

This image shows a bride in white against a white background, so most of the tones in the image are very light. Accordingly, the histogram data is clustered near the right edge of the graph. The image was shot at f/3.2, $\frac{1}{160}$ second, and ISO 800.

In the image of a man in a dark suit against a dark background, most of the tones are dark. Therefore, the histogram data is clustered near the left edge of the graph. The image was shot at f/2.8, $\frac{1}{30}$ second, and ISO 1000.

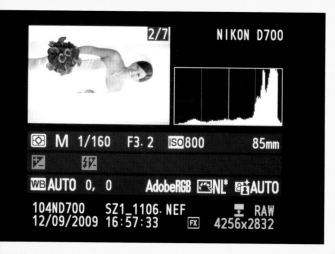

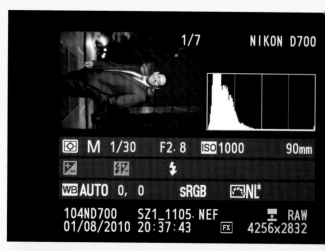

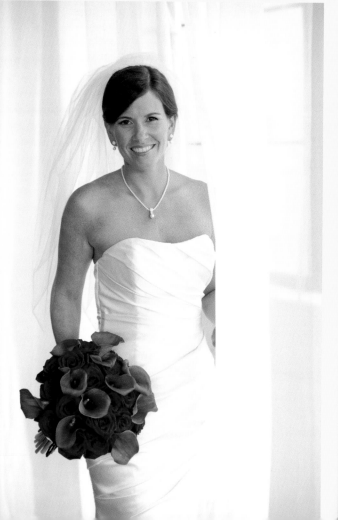

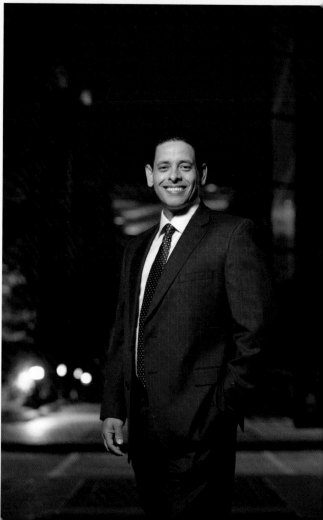

held meters, built-in meters try to provide a correct exposure for a middle gray tone. However, because they measure the light *after* it is reflected by the scene/subject, their readings can be misleading. For example, if we metered a scene with a lot of dark tones that reflect little light—such as a group of groomsmen in tuxedos—

the meter would suggest settings designed to average those black tones to middle gray. The result is overexposure. Likewise, if we metered a scene with lots of light tones—such as snow or a white wedding gown—the in-camera meter would try to underexpose the scene, rendering the white as if it were middle gray. (*Note:* One solution is to use your in-camera meter in the spot metering mode, so it meters a very small portion of the scene—1 to 5 percent. This can allow you to get a specific reading off a certain area and not let the other tones in the scene affect the exposure reading.)

The Camera's Histogram. The camera's histogram can also work as a light meter, helping you determine if the photograph is overexposed, underexposed, or properly exposed. The histogram shows the entire range of information that your camera can capture, from the highlight information, displayed on the right side of the graph, to the shadow information, displayed on the left.

Many people think that a histogram should have a certain shape for every image. However, this fails to take into consideration the dominant tones in different scenes. Even with the same light falling on them, a black cat on a black couch will have a much different histogram than a white vase against a white wall. The histogram is unique to each image and reflects the overall distribution of tones in the capture.

Truth be told, you will have mountains (high points) and valleys (low points) across the histogram. The things that matters most are the end points. A histogram of a good exposure has no spikes at either end. This means that the camera was able to record all the tones properly. In general, you want the right endpoint to come close to the edge of the histogram without hitting it or spiking. A histogram that hits the edge of the graph with a spike indicates that the photo is overexposed. Conversely, a large gap at the right-hand side of the histogram indicates underexposure.

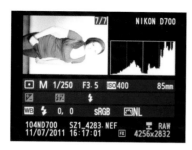
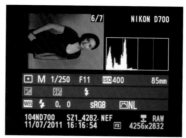

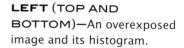

LEFT (TOP AND BOTTOM)—An overexposed image and its histogram.

RIGHT (TOP AND BOTTOM)—An underexposed image and its histogram.

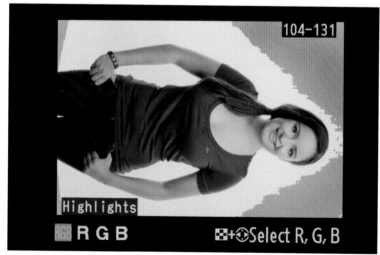

Here we see an overexposed image with blinking highlights. Notice that the blinking part of the image is only on the white background, not on the model. Since we don't care if there is detail in the white background, the blinking highlights are not cause for concern.

You can only use the histogram as a tool to refine exposure for light sources that remain consistent, such as ambient light and manual flash. When making TTL and automatic flash exposures, the light levels will change based on the camera's calculations of how much light to output. Therefore, the histogram can only be

used to confirm the exposure of an individual capture, not to predict any needed change to the exposure for the next capture.

The camera's blinking highlights display will alert you to tones in any part of the frame that are clipped (overexposed to pure white).

This is extremely helpful outdoors when bright sunlight can make it difficult to review the LCD screen. The challenge is knowing how to read the blinking highlights. For example, we don't want to see blinking highlights (meaning overexposure and lack of detail) on a white wedding gown. In that case, we would want to bring down our exposure. On the other hand, we need not worry about a specular highlight (the brightest spot on a shiny object) that might blink when the rest of the scene is properly exposed.

THE INVERSE SQUARE LAW

The inverse square law states that the intensity from a point light source (like a Speedlight) is inversely proportional to the squared distance between the subject and the light source. It is expressed by the formula: $I = 1/d^2$. Where **I** represents the intensity of the light on the subject and **d** represents the distance of the light source from the subject. For example, when you double the distance between your subject and the flash, the law says that the intensity of the light will be reduced to $\frac{1}{4}$ of its original power ($\frac{1}{4} = 1/[2^2]$). This is a 2-stop difference in the exposure.

This has an important implication as to the look of our images. For example, imagine you are photographing a one-light portrait in the studio on a white background. In this setup, the difference in exposure between the light falling on the background and the light falling on the subject will depend on two factors: the distance of the light to your subject and the distance of your subject to the background. Knowing this, you can adjust these distances to produce many different looks on a white background. In fact, your background can be rendered in any tone from white to black depending on the distance of your light to the subject and the distance of the subject to the background.

The inverse square law also shows that when it comes to large group photos, moving your lights back can help provide more

For these two images, Meredith remained six feet from the background. In the first image, a Speedlight in a softbox was placed six feet away from her and the flash was set to properly expose her. This resulted in the background rendering as nearly white. For the second image, the light was moved to about a foot from Meredith (and I adjusted my flash power down to get a proper exposure). In this configuration, the distance between Meredith and the background is much greater than the distance between Meredith and the light. Because the light fall-off is much greater, the background is rendered gray. It was possible to create two very different images by just changing the ratio between the distance of the Speedlight to the subject and the distance of the subject to the background.

even exposure. Let's say you are working with a large group of people that are stacked up a set of stairs. You will choose a greater depth of field to make sure everyone is in focus and you will want to make sure to evenly light everyone from front to back. The farther away your light source, the more evenly lit your scene will be. Do, of course, remember that you will also need more power from your flash since it will be placed farther back.

Conversely, for a greater fall-off of light intensity, move your light in closer. This is a great way to isolate your subject from the background.

WHY IS BOUNCED FLASH SUCH A GREAT OPTION?

As the inverse square law reveals, distance has a large impact on light fall-off. We all know that with on-camera flash, people in the foreground are going to be brighter than people in the background. It's a very simple concept that the farther you move away from the light, the dimmer the light is going to be. So is there any way to use one Speedlight to properly and evenly light two subjects that are a large distance apart? Yes. If you bounce your flash off a wall to the side of your subjects, the light on the subjects will be coming from the direction of the wall, not the camera. Essentially, you are making the distance between the source of light and your subjects about the same, so that they will be exposed more evenly. (*Note:* When doing this, it is important to flag [block part of] your flash so that no light from the Speedlight falls directly onto your subject from the direction of the flash. See chapter 5 for more on this.)

LEFT—Direct on-camera flash properly exposed Meredith, but Brandon, who is standing fifteen feet behind her, is dark due to the light fall-off. (f/5.6, $^1/_{250}$ second, ISO 200) **RIGHT**—Bouncing on-camera flash off a wall to camera left effectively made the wall our light source. The wall was equidistant to Meredith and Brandon, which meant both of them were equally exposed. (*Note:* I flagged my flash so that no light spilled directly from the flash onto Meredith.) (f/5.6, $^1/_{250}$ second, ISO 200)

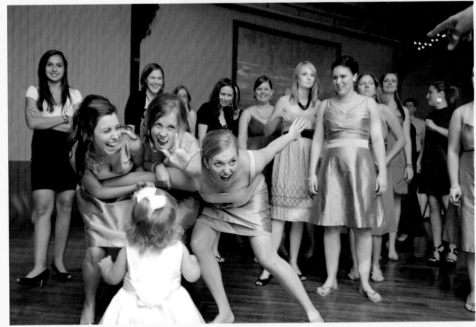

Bounce flash is a powerful technique to put into practice on assignment. Here, I bounced my flash behind me and a bit to camera right, allowing me to fully light the entire group of ladies as they prepared to battle over the tossed bouquet. My light source was now a wall that was equidistant to everyone in the photo. As a result, everyone was evenly lit. (f/2.8, $^1/_{60}$ second, ISO 1600)

WHEN SHOULD YOU CHOOSE TO USE FLASH?

Here's a general guideline: if the existing light isn't interesting, it's time to pull out the Speedlight. There should be no excuse for not improving the quality of the light. The images that follow show situations where adding flash greatly improved the photographs. (*Note:* Some of the final photographs have been retouched and color corrected.)

WITHOUT FLASH (ABOVE)

WITH FLASH
(FACING PAGE)
(f/4, $^1/_{250}$ second, ISO 400)

Alison makes a pretty bride, but the available light was very even and flat. Adding a bit of directed off-camera flash created a much more fashionable image of our bride.

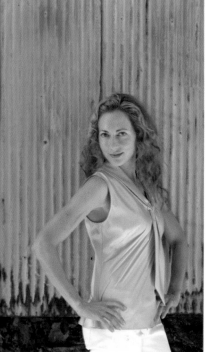

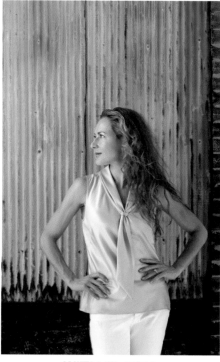

WITHOUT FLASH **WITH FLASH**

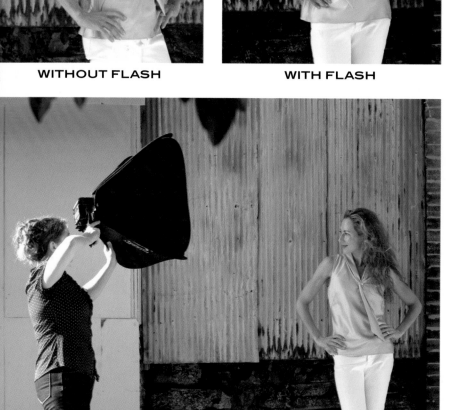

Here, the light bouncing back from the sidewalk created some unattractive lighting patterns on Lindsay. By adding some light from an SB-900 Speedlight in a softbox I was able to decrease the effect of the ambient light and create more flattering lighting on her face. (Flash exposure: f/5.6, $^1/_{250}$ second, ISO 250)

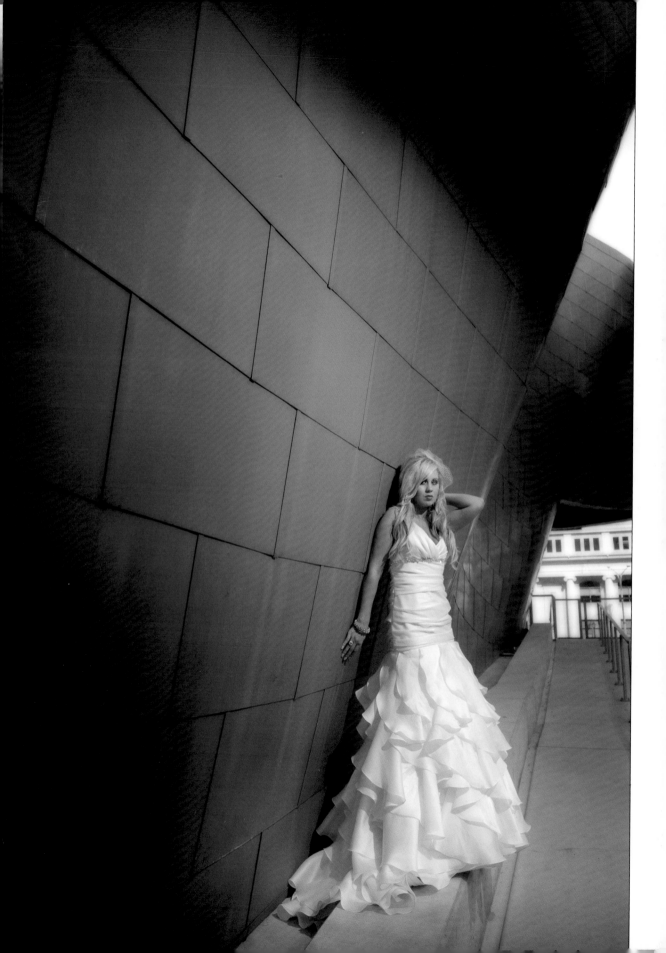

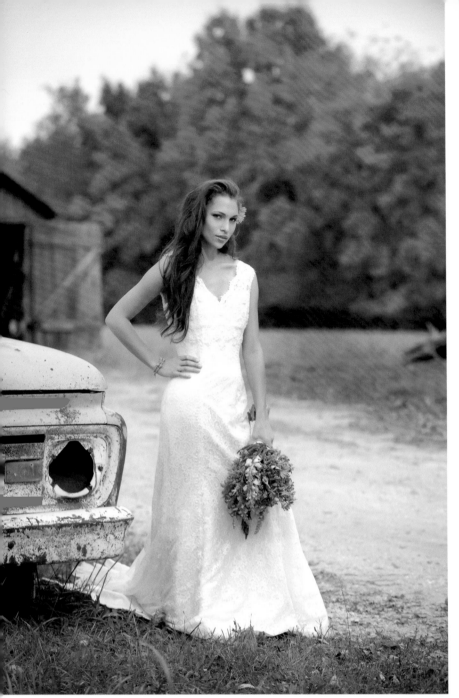

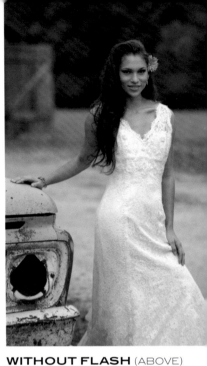

WITHOUT FLASH (ABOVE)

WITH FLASH (LEFT)
f/4.0, $\frac{1}{250}$ second, ISO 640

WITHOUT FLASH (BELOW)

WITH FLASH (FACING PAGE)
f/2.8, $\frac{1}{100}$ second, ISO 800

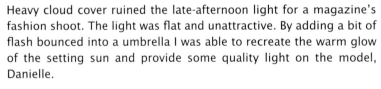

Heavy cloud cover ruined the late-afternoon light for a magazine's fashion shoot. The light was flat and unattractive. By adding a bit of flash bounced into a umbrella I was able to recreate the warm glow of the setting sun and provide some quality light on the model, Danielle.

WITHOUT FLASH (ABOVE)

WITH FLASH
(FACING PAGE)
f/4, $\frac{1}{80}$ second, ISO 1000)

The dull, diffused light caused by heavy cloud cover means that there are no catchlights in Amanda and Tiffany's eyes. The only way to improve the situation was to add flash. In this case, I used an SB-900 bounced into an umbrella.

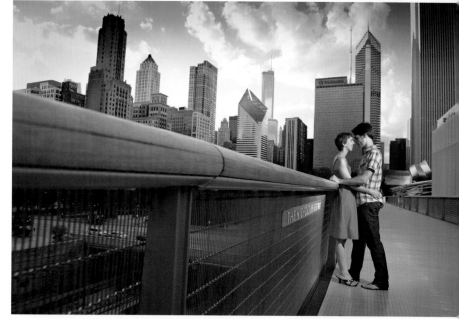

WITH FLASH (TOP)
f/8, $\frac{1}{250}$ second, ISO 100

WITH FLASH (CENTER)
f/5.0, $\frac{1}{250}$ second, ISO 160

WITH FLASH (BOTTOM)
f/8, $\frac{1}{250}$ second, ISO 100

Sometimes there is beautiful, dramatic light in a photograph—but it just doesn't seem to fall on your subject. By properly exposing for the background and adding flash to light your subject you don't have to compromise as to which part of the scene will be properly exposed and look good.

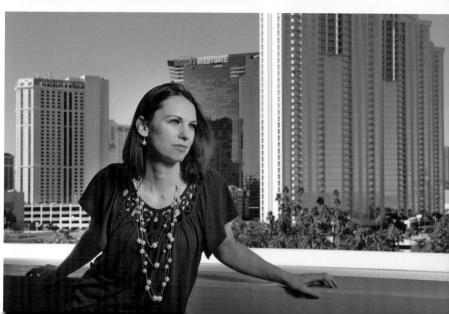

2. THE NIKON SPEEDLIGHT SYSTEM

HOW A FLASH WORKS

On the most basic levels, your flash works by turning it on, triggering it, and having it produce a burst of light. Yet, the technology behind that burst of light is quite sophisticated. As the Nikon Creative Lighting System (CLS) becomes more and more advanced, the control you have over the light it produces becomes even more precise.

A flash is made up of three main components: batteries, a capacitor, and a flashtube. The flashtube (where the burst of flash comes from) contains a tungsten filament runs through an atmosphere of xenon gas. Xenon is very stable; in fact, it requires a lot of energy to make it unstable enough to conduct electricity and produce the flash.

The batteries provide that power. The amazing thing about a flash unit is that it is able to convert the power of four 1.5-volt AA batteries into 5000 volts of energy to excite the xenon gas enough to conduct electricity. This process happens thanks to the use of a transformer, which takes the low voltage from the battery and transforms it into high voltage. The higher voltage is then stored in the capacitor. When the capacitor is full and ready to discharge, the red ready light on the back of the flash will light up.

When you trigger the flash, part of the charge stored in the capacitor is transformed again to an even higher voltage. This destabilizes the xenon gas and makes it release electrons, a process called ionization. Once the gas is ionized, it is highly conductive and the electrons stored in the capacitor run through the flash tube, colliding with the gas atoms. It is the combinations of billions of these collisions—in a matter of milliseconds—that create a flash of light.

Today's flash units feature transistors known as IGBTs (insulated gate bipolar transistors) that stop the flash from firing when a sensor determines that the correct amount of light has been produced. They are an integral part of automatic and TTL flash technology.

One thing that should be noted about any flash is that the power setting determines *how long* the flash will burn, not *how brightly* it will burn. A flash will only fire at one set intensity, but the longer a flash fires, the more light it produces—and, obviously, the longer the flash fires, the more energy it needs. That's why some photographers refer to a full-power exposure as a "full dump." The capacitor needs to release all the energy it has stored just to power that one

flash exposure. It might then take a few moments for the capacitor to recharge for the next flash exposure. This is important to note so that you don't take photographs at a faster rate than your Speedlight can handle. Taking another photograph before the flash has fully recycled will lead to underexposed photos. (*Note:* Using fresh batteries will improve the recycle time of the flash.)

CLS FEATURES AND FUNCTIONS

As mentioned earlier, the Nikon Creative Lighting System (CLS) gives you precise control over the light produced by your Speedlight. This happens by taking advantage of the camera's digital communication capabilities. The following is a brief description of the features that CLS flashes have when used with compatible Nikon cameras. We will look at how to use these features in the following chapters.

i-TTL/i-TTL BL Mode. This is the Nikon Creative Lighting System's TTL auto flash mode. Multiple pre-flashes are fired milliseconds before the flash fires and measured instantaneously by the camera to determine the correct flash exposure prior to taking the photo. The information from the pre-flashes, along with the information from the in-camera light meter is combined to determine how much flash output is needed in the i-TTL mode or how to balance the output with the ambient light in the i-TTL BL mode. The built-in flashes of CLS compatible cameras also use the i-TTL mode.

Advanced Wireless Lighting. This is probably one of the most useful tools of the CLS. Advanced Wireless Lighting (AWL) lets you use multiple Speedlights wirelessly off-camera in TTL mode (though you can also fire the flashes in other modes). You can control the power output of multiple flashes in up to three different groups on four different channels.

Flash Value Lock. Using the flash value (FV) lock allows you to set the flash exposure for the subject and then recompose your frame. The FV will stay the same even if you change your aperture or your composition or zoom your lens.

Flash Color Information Communication. The Speedlight's power is determined by the duration of the flash exposure. Shorter durations tend to have cooler color temperatures, while greater flash power and longer durations tend to have warmer color temperatures. With the Nikon system, the Speedlight automatically transmits information about the correct color temperature to the camera. The camera needs to be set to the flash or automatic white-balance mode to take advantage of this feature.

Auto FP High-Speed Sync. This feature allows you to use a higher shutter speed than your camera's maximum flash sync speed (see chapter 3). It works by emitting a constant series of low-power flashes during the duration of the exposure. This is useful when working with action shots that demand high shutter speeds to stop the action. It is also useful when you want a wider aperture for a shallower depth of field and therefore require a faster shutter speed for proper exposure.

AF-Assist Illuminator. The Speedlight has a built in LED that projects a red beam onto your subject when working in low-light situations. This helps the camera's autofocus system lock onto your subject. It is important to note that the AF-assist illuminator does not work when

the camera is in continuous autofocus or manual focus mode.

NIKON CLS FLASH UNITS

The SB-900 is the current flagship of the Nikon CLS system. It is the most powerful and most advanced Speedlight Nikon produces. The smaller and slightly less powerful SB-700 has fewer features than the SB-900 but boasts more intuitive and easy-to-use features and controls. The SB-400 is a very basic flash that is good for photographers looking for more power and control than their camera's built-in flash.

THE SB-900

❶ **Flash Head.** This contains the flash tube and the zoom mechanism that pushes the flash

SB-900 front.

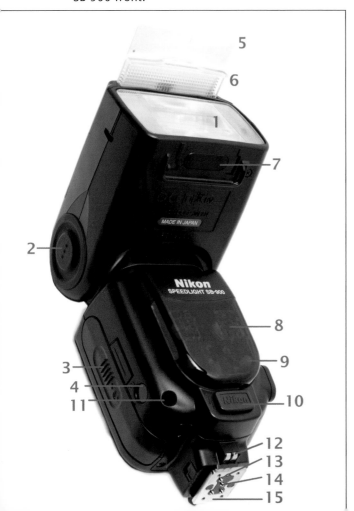

tube forwards and backwards. The SB-900 automatically senses the focal length of attached compatible lenses and adjusts the flash tube's position.

❷ **Flash Head Tilt/Rotate Lock Release Button.** Allows the flash head to tilt down to –7 degrees or up to 90 degrees with click-stops at –7, 0, 45, 60, 75, and 90 degrees. The flash head rotates horizontally 180 degrees to the left and right.

❸ **Battery Chamber Lid.** The SB-900 holds four AA batteries.

❹ **Light Sensor Window for Wireless Remote Flash.** This is the sensor that receives signals from the master flash when the SB-900 is working as a remote.

❺ **Bounce Card.** This small plastic card is pulled out with the wide-flash adaptor. It is used to provide a bit of bounce-back fill light when the flash head is pointed directly upward to bounce flash off the ceiling.

❻ **Wide-Flash Adapter.** This pull-out diffuser spreads the light from the flash to fully illuminate the angle covered by a 14mm lens. The zoom on the flash is automatically set to 14mm when the adapter is in use.

❼ **Filter Detector.** Nikon's filters have a special code on them that the flash reads to determine the filter color. The filter is placed in a supplied filter holder.

❽ **AF-Assist Illuminator.** In low light situations, a built-in LED projects a red beam onto your subject. This helps the camera's autofocus system lock focus on your subject.

❾ **Ready Light (at Remote Settings).** This will light up red when the flash is ready to fire.

❿ **External Power Source Terminal.** This terminal allows you to attach the SB-900 to the SD-9 battery pack, which provides quicker recycle times.

⓫ **Light Sensor for Non-TTL Auto Flash.** This allows the flash to meter the light reflecting

off the subject externally instead of using TTL (through the lens) metering.

⑫ **External AF-Assist Illuminator Contacts.** This communicates with the camera when the AF-assist illuminator is needed.

⑬ **Mount Pin.** When you turn the mounting foot lock lever, the mount pin drops down to lock the flash into the hot shoe.

⑭ **Hot Shoe Contacts.** These four pins connect to the contacts in the hot shoe of Nikon cameras. They transmit information between the camera to the flash.

⑮ **Mounting Foot.** This attaches the flash to the camera's hot shoe.

⑯ **Flash Head Tilting Angle Scale.** This scale shows the angle that the flash head is positioned vertically. The flash head tilts down to –7 degrees or up to 90 degrees.

⑰ **Flash Head Rotating Angle Scale.** This scale shows the angle that the flash head can tilt horizontally. The flash can tilt 180 degrees from left to right.

⑱ **Sync Terminal.** Allows you to use a sync cord to fire your SB-900 flash.

⑲ **LCD Panel.** Displays the current settings of your flash and allows access to the flash menu and advanced settings.

⑳ **Flash Ready Light.** This light shows that the flash is ready to discharge.

㉑ **Mounting Foot Lock Lever.** Turning this lever locks the flash into the hot shoe.

㉒ **MODE button.** Press to select the flash mode.

㉓ **ZOOM button.** Press to adjust the zoom position of the flash tube.

㉔ **Function buttons.** For all of the function buttons, press to select which item to change. The functions differ according to the flash mode and status. See the section on flash modes in chapter 3 for specific instructions on the function buttons.

㉕ **Test Firing Button.** Press to test fire the flash. The SB-900 also has a modeling illumi-

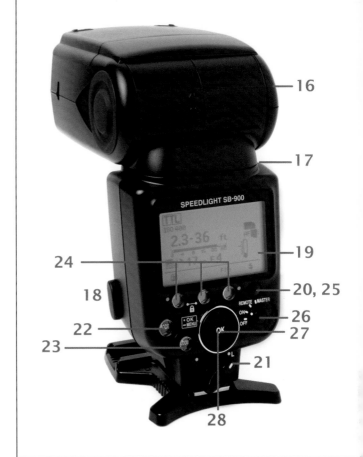

SB-900 back.

nator function. The flash will fire at a reduced output for approximately 1.5 seconds. This is used to check the direction of lighting and the shadows falling on a subject before actually taking the photograph. The modeling illuminator must be activated in the custom setting menu.

㉖ **Power Switch/Wireless Setting Switch.** Turns the flash on or off—and either to a master unit or a remote unit when using the wireless lighting system. To switch to master or remote, you must press down the button in the middle of the switch when turning it.

㉗ **Selector dial.** Rotate the selector dial to change the selected item.

㉘ **OK button.** Lightly press to confirm a setting. Hold down for one second to display the custom function menu.

THE SB-700

❶ Flash Head. This contains the flash tube and the zoom mechanism that pushes the flash tube forward and backward. The SB-700 automatically senses the focal length of attached compatible lenses and adjusts the flash tube's position.

❷ Flash Head Tilt/Rotate Lock Release Button. Allows the flash head to tilt down to –7 degrees or up to 90 degrees with click-stops at –7, 0, 45, 60, 75, and 90 degrees. The flash head rotates horizontally 180 degrees to the left and right.

❸ Light Sensor Window for Wireless Remote Flash. This is the sensor that receives signals from the master when the SB-700 is working as a remote.

SB-700 front.

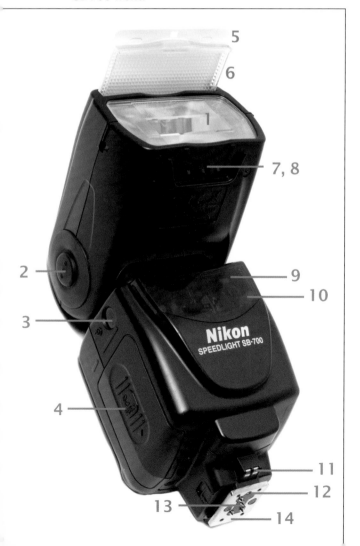

❹ Battery Chamber Lid. The SB-700 holds four AA batteries.

❺ Bounce Card. This small plastic card is pulled out with the wide-flash adaptor. It is used to provide a bit of bounce-back fill light when the flash head is pointed directly upward to bounce flash off the ceiling.

❻ Wide-Flash Adaptor. This pull-out diffuser spreads light from the flash to fully illuminate the angle covered by a 14mm lens. The zoom on the flash is automatically set to 14mm when the adapter is in use.

❼ Filter detector. Nikon's filters have a special code on them that the flash reads to determine the filter color. The filter is placed in a supplied filter holder.

❽ Nikon Diffusion Dome Detector. Detects when a diffusion dome is attached to the flash and adjusts the zoom head accordingly.

❾ Flash Ready Light (at Remote Settings). This will light up red when the flash is ready to fire.

❿ AF-Assist Illuminator. In low light situations, a built-in LED projects a red beam onto your subject. This helps the camera's autofocus system lock focus on your subject.

⓫ External AF-Assist Illuminator Contacts. This communicates with the camera when the AF assist is needed.

⓬ Mount Pin. When you turn the mounting foot lock lever, the mount pin drops down to lock the flash into the hot shoe.

⓭ Hot Shoe Contacts. These four pins connect to the contacts in the hot shoe of the Nikon cameras. They transmit information from the camera to the flash and vice versa.

⓮ Mounting Foot. This attaches the flash to the camera's hot shoe.

⓯ Flash Head Tilting Angle Scale. This scale shows the angle that the flash head is positioned vertically. The flash head tilts down to –7 degrees or up to 90 degrees.

⑯ Flash Head Rotating Angle Scale. This scale (just below the flash head) shows the angle that the flash head can tilt horizontally. The flash can tilt 180 degrees from left to right.

⑰ Flash Ready Light. This shows that the flash is ready to discharge.

⑱ LCD Panel. Displays the current settings of your flash and allows access to the flash menu and advanced settings.

⑲ Mounting Foot Lock Lever. Turning this lever locks the flash into the hot shoe.

⑳ Mode Selector. Slide to select the flash mode.

㉑ ZOOM Button. Press to adjust the zoom position of the flash tube.

㉒ Test Firing Button. Press to test fire the flash.

㉓ Menu Button. Press to display the custom menu settings.

㉔ Selector Dial. You can rotate the selector dial to change the selected item.

㉕ Illumination Pattern Selector. Slide the lever to select the flash illumination pattern. There are three different illumination patterns you can choose: standard, center-weighted, and even.

㉖ Select Button. This button selects the item to be configured.

㉗ Power On/Off Switch and Wireless Setting Switch. Turns the flash on or off—and either to a master unit or a remote unit when using the wireless lighting system. To switch to master or remote, you must press down the button in the middle of the switch when turning it.

㉘ OK button. Lightly press to confirm a setting.

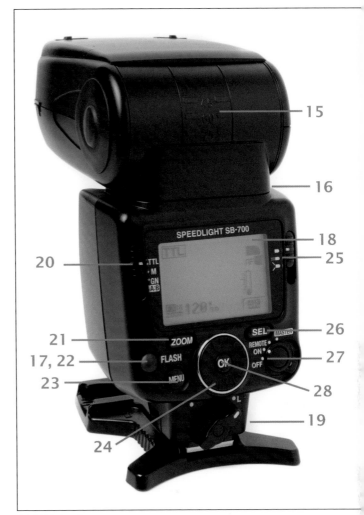

SB-700 back.

THE SB-400

The SB-400 is the simplest of the Nikon Speedlights. In fact, the only switch is an on/off switch. The flash works only in i-TTL mode (except when shooting with the D40, where you can set it to manual via the camera). It does work in all the flash sync modes as set on the camera body. One of the features of the SB-400 is a tilting flash head that allows you to bounce flash. The flash tilts from horizontal (straight-on flash) to 90 degrees vertical (straight-up bounced flash).

❶ **Battery Chamber Lid.** The SB-400 takes two AA batteries.

❷ **Mounting Foot.** This attaches the flash to the camera's hot shoe.

❸ **Mounting Foot Locking Lever.** Turning this lever locks the flash into the hot shoe.

❹ **On/Off Switch.** Turns the power on or off.

❺ **Ready Light.** When the ready light is on, the flash is fully charged and ready to fire at full power. The light will blink if there is a problem with the flash, such as low battery power or if the flash is overheated.

Comparison Between the SB-700 and the SB-900. While the SB-700 is a very powerful, compact flash with a lot of useful features, it is missing a few things that the SB-900 offers. One of the big features of the Nikon CLS is the ability to use the Speedlights for wireless off-camera lighting. The SB-700 only controls two remote groups in master mode, while the SB-900 (and SU-800; covered in the next section) controls

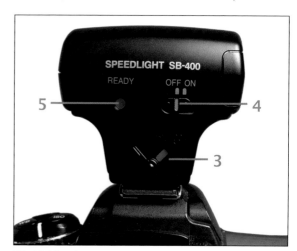

SB-400 back.

SB-400 front.

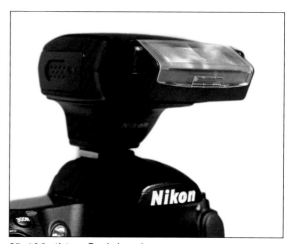

SB-400 tilting flash head.

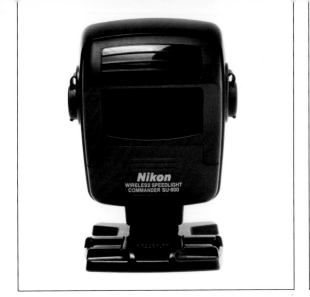

SU-800 front.

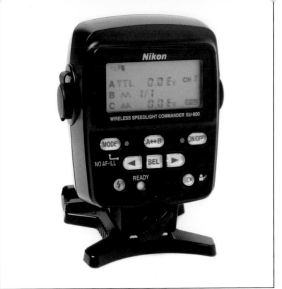

SU-800 back.

three groups. (The SB-700 works in three groups in remote mode.) Another disadvantage of the SB-700 in master mode is that all the flashes have to be in the same flash mode. If you shoot in TTL, all of your remote flashes will also fire in TTL. With the SB-900 (and SU-800), you can choose to have one group in TTL and another group in manual mode. The final missing feature on the SB-700 is the external power source terminal that allows you to attach it to an external battery pack, which improves recycle times.

One of the improvements in the SB-700 is in the thermal protection mode. Nikon first introduced a thermal protection mode on the SB-900. This is a very useful mode that preserves the life of your flash by monitoring the temperature of the flash head and disabling use when critical temperatures are reached—however, your SB-900 Speedlight will shut down when it reaches those temperatures, and you will have to wait until the flash cools down before being able to use it again. (This mode can be disabled in the custom function menu.) The newer SB-700 upgrades this with a more intelligent system for

heat control. It protects the flash head against excessive heat while still allowing continued operation. It's able to do this by slowing down the recycling time so that the rate of heat-producing flashes is also slowed.

The controls on the SB-700 are also a little more intuitive and accessible compared to the SB-900. The flash exposure modes and flash illumination patterns are easier to change via switches on the back of the flash instead of function and menu choices.

CONTROLLERS

SU-800. The SU-800 is a wireless Speedlight commander. A commander triggers the remote flashes, reads the responding pre-flashes, and conveys that information to the camera so that it can calculate the proper exposure.

The SU-800 works much like an SB-900 or SB-700 set to master mode, except that it doesn't emit any visible light. Its sole purpose is to transmit and receive information from the remote flashes. It does this by sending infrared pulses to communicate with the remote Speed-

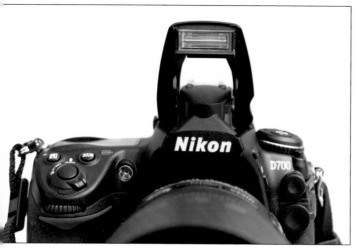
Built-in flash on the D700.

lights. The commander and remote units need to be in line-of-sight with one another for this to work (the light sensor window for the wireless flash needs to be able to see the pulses from the commander). The remote flash will not fire if anything is blocking its view of the commander.

The SU-800 is able to control three different groups of flashes (A, B, and C) in TTL, auto, and manual modes. Each flash group can be set to a different flash mode and their power outputs can be individually controlled. It also works on four different channels.

Built-In Camera Flashes. A few of the Nikon cameras, including the D700 and the D300s, have built-in pop-up flashes. For someone who is serious about using flash in a dramatic, interesting, and professional manner, I wouldn't recommend relying solely on the pop-up flash. It has minimal power compared to the Nikon Speedlights and your only option is direct flash, which produces a very harsh look.

However, the pop-up flashes of the D700 and D300s do offer an extremely useful feature for advanced wireless lighting. Using the camera's

flash menu, you can set the built-in flash to function as a commander/master flash. (See your camera's manual for instructions on how to set it up.) This allows you to control two different groups of remote Speedlights in the TTL, auto, or manual mode. When using the built-in flash on the camera, it must be set to the commander mode to allow for the remote Speedlights to work in high-speed sync mode.

It should also be noted that when the built-in flash is used in the commander mode, the preflash can sometimes be added to the exposure. This is usually an issue only when working with up-close macro photography, and it can be addressed using a Nikon SG-3IR—a small plastic device that fits into the camera's hot shoe and suspends an infrared filter in front of the built-in flash. This filter blocks the output of the flash but still allows the triggering information for the remote flashes to be transmitted.

R1C1 KIT AND SB-R200

Close-up photography and macrophotography can be challenging to light. Using a regular on-

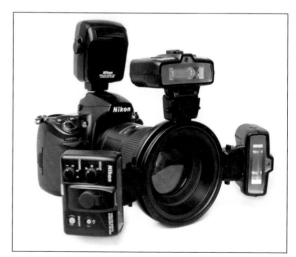
R1C1 kit and SB-R200.

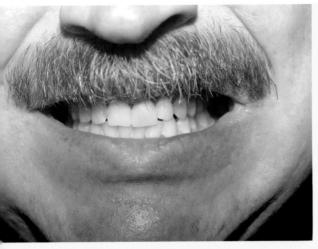

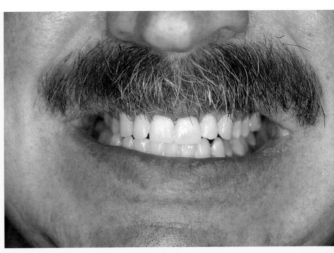

WITH ON-CAMERA SB-900

WITH R1C1 KIT

The original ring light was created by a dentist in the 1950s. Today, many dentists use the R1C1 kit to take photos of the mouth that show all the teeth.

camera Speedlight can cause unsightly shadows on your subject. To correct this issue, you'll want to move your flash closer to your lens to get more even and controlled lighting. The R1C1 kit provides even illumination with few visible shadows, functioning essentially as a ring light.

The R1C1 kit consists of an SU-800 Speedlight commander unit, two SB-R200 Speedlights, and an SX-1 attachment ring. The attachment ring clips on to the front of your lens via a special adaptor that fits the specific lens you are using. The SB-R200 units clip on to that attachment ring. You can then affix up to eight SB-200 units to the attachment ring. The commander

unit wirelessly controls the flashes. The SU-800 also lets you control additional Speedlights, such as an SB-700 set as a background light. This opens up a lot of opportunities for creative macrophotography.

Putting the R1C1 Kit into Practice. In the photos of citrus fruit shown below and continuing on the next page, I wanted to emphasize all the different segments of the fruit. I used the R1C1 kit so that I had even illumination across my frame while working so close to my subject.

The fruit was laid out on a piece of glass so that I could backlight it. The first photo shows no backlighting. In the second photo, I bounced a

The lighting setup.

R1C1 kit without backlight.

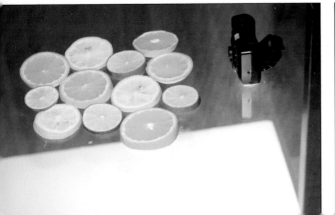

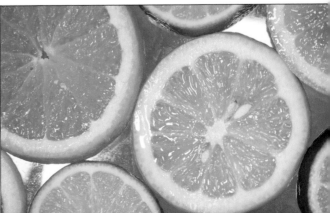

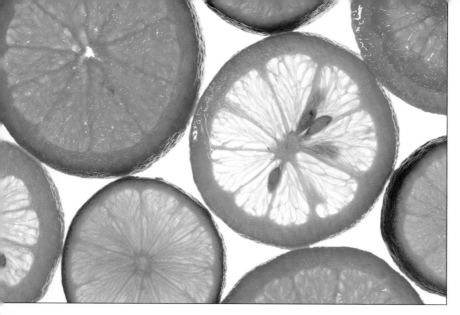

R1C1 kit with backlight.

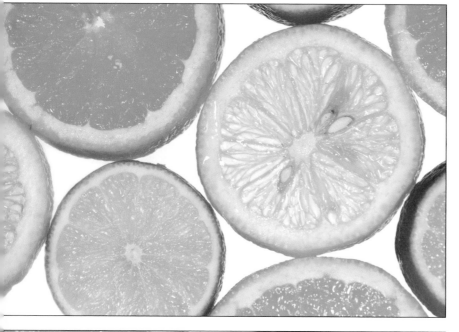

R1C1 kit with background light powered down 1 stop. (f/8, $\frac{1}{60}$ second, ISO 400)

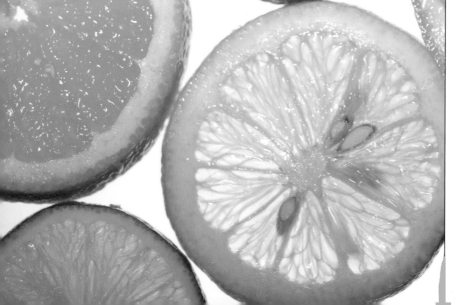

For comparison, this photo was taken with the SB-900 on the camera. Notice the light fall-off on the bottom of the photograph. This is a common occurrence with on-camera flash and macrophotography.

LEFT—The Speedlight stand. **RIGHT**—Colored filter set.

flash onto a white foam-core board placed about 2 feet beneath the glass. The resulting backlight was a little too strong for my taste, so I reduced the flash power by 1 stop to get the lighting I wanted in the final image.

ACCESSORIES

The SB-900 and the SB-700 come with several accessories that make your flash more versatile and give you more control over your lighting quality.

The Speedlight Stand. The Speedlight stand provides a compact, stable base for a remote flash so it can stand on its own. It has a slot for the Speedlight's foot that allows you to attach the Speedlight to the stand the same way you would attach it to the camera. The stand also features a standard $\frac{1}{4}$ inch, 20tpi (threads per inch) socket so that you can attach it to a light stand or tripod. Because the flash locks securely into the stand, I find it to be much more stable and reliable than a cold-shoe connector when attaching the Speedlight to a light stand.

Colored Filter Set. Colored filters are supplied with the SB-900 and SB-700. They balance the Speedlight's color temperature to the color temperature of the existing light in a scene.

The SB-900 comes with a filter holder and four different acetate filters: two green ones for fluorescent lighting and two orange ones for incandescent lighting. The gels have a silver identification code on them. When the filter holder is attached to the flash and the code lines up properly with the filter detector, the flash will automatically recognize the type of filter on the flash.

Diffusion dome.

You can check that the Speedlight is recognizing the filter on the Speedlight's LCD panel.

The SB-700 comes with two hard plastic filters: a green one for florescent lighting and an orange one for incandescent lighting. The filters attach directly to the flash head.

Diffusion Domes. Both the SB-700 and the SB-900 come with a diffusion dome that attaches over the flash head and filter.

POWERING THE FLASH

No matter how powerful and capable your Speedlight is, you need to have the proper power supply to take advantage of all it has to offer.

Batteries. The SB-900 and the SB-700 run off four 1.5-volt AA batteries, but not all batteries are created equal. There are several factors you'll want to take into consideration when choosing which batteries to buy.

> **How much do the batteries cost?** Single-use alkaline batteries will cost less initially than rechargeable batteries, but rechargeable batteries will quickly pay for themselves. There is also the environmental cost to consider. Most batteries end up in landfills leaking toxic chemicals. Rechargeable batteries help keep a few more batteries out of our landfills.
>
> **How long will the battery stay charged?** No battery will stay charged forever. It's important to know how long the batteries will hold their charge. Some rechargeable batteries start losing their charge within 24 hours of being charged—even when they are not in use. Other batteries will hold their charge for a long time, but have less capacity and lower performance.
>
> **How much capacity does the battery have?** Capacity relates to how many flash exposures you can get out of a set of batteries. High-capacity batteries deliver on performance, but they generally do not hold their charge for very long. Conversely, long-life batteries hold their charge for a long time but have less capacity.
>
> **What are the recycle times for the batteries?** You want a battery that will be able to deliver power to the capacitor at a speed that will allow your flash to recycle at speeds consistent with your shooting style.
>
> **How hot do the batteries get?** Heat is the enemy of any electrical product. If your batteries heat up too much when they discharge energy, they could damage the electronics of your Speedlight. The more rapidly the batteries discharge, the hotter they will get.

There are three main types of batteries: single-use alkaline batteries, single-use lithium batteries, and rechargeable nickel-metal hydride (NiMH) batteries.

One benefit of single-use alkaline batteries is that they can be purchased almost anywhere—from gas stations to department stores. Alkaline batteries are relatively inexpensive, and they have a long shelf life. There is a difference in performance between the different brands of alkaline batteries. As with many things, you get what you

pay for. Alkaline batteries work fine, but as you start demanding more power and performance out of your Speedlight, you will want something with a higher capacity and better recycle times.

Single-use lithium batteries have several benefits. They have a long shelf life (they keep their charge), they operate in almost every climate/temperature, and they are almost half the weight of normal alkaline batteries. However, because of their long life span, they quickly lose some of their ability to deliver power. They are also more expensive than regular alkaline batteries. However, if you choose to go the route of rechargeable batteries, it is a good idea to keep a set of lithium batteries in your bag. If you run out of power from your rechargeable batteries, these will be ready to go in a pinch.

Nickel-metal hydride (NiMH) rechargeable batteries are a great option for people who regularly use their Speedlights. They deliver the high capacity and quick recycle times that your flash needs. While they might be more expensive initially, they are cheaper in the long run.

The only negative to rechargeable batteries is that they self-discharge. In the first 24 hours after charging, they can discharge up to 10 percent of their capacity and an additional 1 percent each day afterwards. That makes it important to charge them close to when you will use them.

Alkaline, lithium, nickel-metal hydride (NiMH) rechargeable, and low-discharge nickel-metal hydride (LD-NiMH) rechargeable batteries.

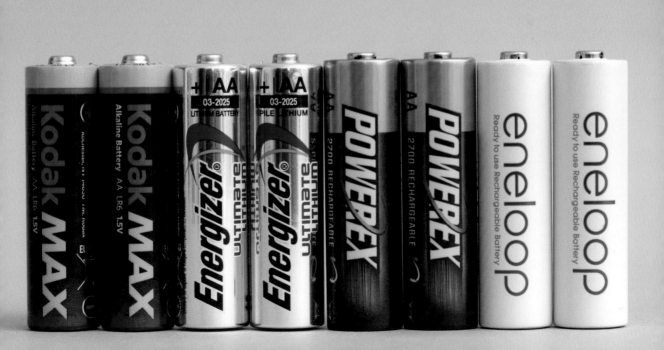

If you don't have the ability to charge them right before a session, low-discharge nickel-metal hydride (LD-NiMH) rechargeable batteries are an option. They have a slightly lower capacity than regular NiMH batteries, but they will hold up to 80 percent of their charge for up to a year.

Battery Packs. The SD-9 high-performance battery pack is a useful tool to help you shorten the recycling time of your flash and increase your flash capacity. It operates on four or eight AA alkaline, lithium, or NiMH batteries. It is only compatible with the SB-900 Speedlight. The SB-700 and SB-400 Speedlights do not have the ability to be connected to a battery pack.

The SD-9 is valuable in any situation when you will be using your flash extensively, but especially when working with wireless remote Speedlights. For Advanced Wireless Lighting (or AWL; see chapter 6) to work properly, the master Speedlight needs to transmit a series of indiscernible pre-flashes that communicate the TTL information to the remote Speedlights. If the battery power is low or the capacitor is not fully charged, the master might not be able to communicate the complete information to the remote Speedlights. This could cause the remote Speedlights to misfire or give an improper flash exposure. It is always important to have fully charged batteries when working with the AWL system. The SD-9 improves both the recycle time and flash capacity to increase performance.

SD-9 high-performance battery pack.

3. SETTINGS, FUNCTIONS, AND MENUS

GUIDE NUMBERS

Before we get into all the different flash shooting modes, it's a good idea to have a proper understanding of guide numbers—what they mean and how they relate to your flash exposure.

A flash's guide number (GN) represents the amount of light that it will produce at a certain ISO and zoom head position. If we know the guide numbers for a certain flash, we know how powerful the flash is. That will help us decide which Speedlight will fit our photographic needs. The higher the GN, the more powerful the flash.

Guide numbers also determine the correct aperture for flash exposure at a specific distance and ISO setting. This is very useful when working with manual flash. When you know the GN of your flash and the distance of the subject to the flash, you know the aperture necessary to make a correct exposure. Remember that with manual flash, the aperture, ISO, and distance are the only things that affect the flash exposure. (Shutter speed affects the ambient light only; it will not affect the flash exposure.)

THIS IS VERY USEFUL WHEN WORKING WITH MANUAL FLASH . . .

To determine the correct aperture (A) at a set ISO and zoom head position, simply divide the guide number by the distance (D) of the flash to the subject ($GN/D = A$). Conversely, if you know the aperture you want to work at (again, at a set ISO and zoom head position), you can divide the GN by the aperture to find out how far your subject needs to be from the flash ($GN/A = D$).

Note that when we are talking about distance for flash exposure, we mean the subject's distance from the flash. For example, you have an off-camera flash 10 feet from your subject and you are able to determine a proper flash exposure setting. Whether you position your camera 1 foot from the subject or 100 feet from the subject, the flash exposure will not change as long as the flash stays stationary. This is a benefit of off-camera flash.

The accompanying charts show the guide numbers for the SB-900 in both the DX and FX modes, as well as for the SB-700. (Note that all GN are for ISO 100 and each of the different zoom head positions.)

SB-900 Guide Number Table (in DX Format)

Standard Illumination Pattern at ISO 100 (m/ft)

Flash Output Level	10 WP + BA	10 BA	10 WP	12	14	16	17	18	20	24	28	35	50	70	85	105	120	135	180	200
1/1	13/42.7	16/52.5	17/55.8	23/75.5	25/82.0	27/88.6	29/95.1	30/98.4	31/101.7	34/111.5	36/118.1	40/131.2	46/150.9	49.5/162.4	51/167.3	52.5/172.2	24.8/81.4	25.7/84.3	56.5/185.4	57/187
1/2	9.1/29.9	11.3/37	12/39.3	16.2/53.1	17.6/57.7	19/62.3	20.5/67.3	21.2/69.6	21.9/71.9	24/78.7	25.4/83.3	28.2/92.5	32.5/106.6	35/114.8	36/118.1	37.1/121.7	17.5/57.4	18.1/59.4	39.9/130.9	40.3/132.2
1/4	6.5/21.3	8/26.2	8.5/27.9	11.5/37.7	12.5/41.0	13.5/44.3	14.5/47.6	15/49.2	15.5/50.9	17/55.8	18/59.0	20/65.6	23/75.5	24.7/81.0	25.5/83.7	26.2/86.0	12.4/40.7	12.8/42.0	28.2/92.5	28.5/93.5
1/8	4.5/14.8	5.6/18.8	6/19.7	8.1/26.6	8.8/28.9	9.5/31.2	10.2/33.5	10.6/34.8	10.9/35.8	12/39.3	12.7/41.7	14.1/46.3	16.2/53.1	17.5/57.4	18/59.0	18.5/60.7	8.7/28.5	9/29.5	19.9/65.3	20.1/65.9
1/16	3.2/10.5	4/13.1	4.2/13.8	5.7/18.7	6.2/20.3	6.7/21.9	7.2/23.6	7.5/24.6	7.7/25.3	8.5/27.9	9/29.5	10/32.8	11.5/37.7	12.6/40.4	12.7/41.7	13.1/43.0	6.2/20.3	6.4/21	14.1/46.3	14.2/46.6
1/32	2.2/7.2	2.8/9.2	3/9.8	4/13.1	4.4/14.4	4.7/15.4	5.1/16.7	5.3/17.4	5.4/17.7	6/19.7	6.3/20.7	7/23.0	8.1/26.6	8.7/28.5	9/29.5	9.2/30.2	4.3/14.1	4.5/14.8	9/32.5	10/32.8
1/64	1.6/5.2	2/6.6	2.1/6.9	2.8/9.2	3.1/10.2	3.3/10.8	3.6/11.8	3.7/12.1	3.8/12.5	4.2/13.8	4.5/14.8	5/16.4	5.7/18.7	6.1/20.0	6.3/20.7	6.5/21.3	3.1/10.2	3.2/10.5	7/23.0	7.1/23.3
1/128	1.1/3.6	1.4/4.6	1.5/4.9	2/6.6	2.2/7.2	2.3/7.5	2.5/8.2	2.6/8.5	2.7/8.9	3/9.8	3.1/10.2	3.5/11.5	4/13.1	4.3/14.1	4.5/14.8	4.6/15.1	2.1/6.9	2.2/7.2	4.9/16.1	5/16.4

BA: With the Nikon diffusion dome attached.
WP: With the built-in wide panel in place.

SB-900 Guide Number Table (in FX Format)

Standard Illumination Pattern at ISO 100 (m/ft)

Flash Output Level	Zoom head position (mm)																
	14			17	18	20	24	28	35	50	70	85	105	120	135	180	200
	WP + BA	BA	WP														
1/1	13/ 42.7	16/ 52.5	17/ 55.8	22/ 72.2	23/ 75.5	24/ 78.7	27/ 88.6	30/ 98.4	34/ 111.5	40/ 131.2	44/ 144.1	47/ 154.2	49.5/ 162.4	51/ 167.3	51.5/ 169.0	54/ 117.2	56/ 183.7
1/2	9.1/ 29.9	11.3/ 37	12/ 39.3	15.5/ 50.9	16.2/ 53.1	16.9/ 55.4	19/ 62.3	21.2/ 69.6	24/ 78.7	28.2/ 92.5	31.1/ 102.0	33.2/ 108.9	35/ 114.8	36/ 118.1	36.4/ 119.4	38.1/ 125.0	39.5/ 129.6
1/4	6.5/ 21.3	8/ 26.2	8.5/ 27.9	11/ 36.1	11.5/ 37.7	12/ 39.3	13.5/ 44.3	15/ 49.2	17/ 55.8	20/ 65.6	22/ 72.2	23.5/ 77.1	24.7/ 81.0	25.5/ 83.7	25.7/ 84.3	27/ 88.6	28/ 91.9
1/8	4.5/ 14.8	5.6/ 18.8	6/ 19.7	7.7/ 25.3	8.1/ 26.6	8.4/ 27.6	9.5/ 31.2	10.6/ 34.8	12/ 39.3	14.1/ 46.3	15.5/ 50.9	16.6/ 54.5	17.5/ 57.4	18/ 59.0	18.2/ 59.7	19/ 62.3	19.7/ 64.6
1/16	3.2/ 10.5	4/ 13.1	4.2/ 13.8	5.5/ 18.0	5.7/ 18.7	6/ 19.7	6.7/ 21.9	7.5/ 24.6	8.5/ 27.9	10/ 32.8	11/ 36.1	11.7/ 38.4	12.6/ 40.4	12.7/ 41.7	12.8/ 42.0	13.5/ 44.3	14/ 45.9
1/32	2.2/ 7.2	2.8/ 9.2	3/ 9.8	3.8/ 12.5	4/ 13.1	4.2/ 13.8	4.7/ 15.4	5.3/ 17.4	6/ 19.7	7/ 23.0	7.7/ 25.3	8.3/ 27.2	8.7/ 28.5	9/ 29.5	9.1/ 29.9	9.5/ 31.2	9.8/ 32.1
1/64	1.6/ 5.2	2/ 6.6	2.1/ 6.9	2.7/ 8.9	2.8/ 9.2	3/ 9.8	3.3/ 10.8	3.7/ 12.1	4.2/ 13.8	5/ 16.4	5.5/ 18	5.8/ 19.0	6.1/ 20.0	6.3/ 20.7	6.4/ 21.0	6.7/ 21.9	7/ 23.0
1/128	1.1/ 3.6	1.4/ 4.6	1.5/ 4.9	1.9/ 6.2	2/ 6.6	2.1/ 6.9	2.3/ 7.5	2.6/ 8.5	3/ 9.8	3.5/ 11.5	3.8/ 12.5	4.1/ 13.5	4.3/ 14.1	4.5/ 14.8	4.5/ 14.8	4.7/ 15.4	4.9/ 16.1

BA: With the Nikon diffusion dome attached.
WP: With the built-in wide panel in place.

SB-700 Guide Number Table (in DX Format)

Standard Illumination Pattern at ISO 100 (m/ft)

Flash Output Level	Zoom head position (mm)													
	10			16	17	18	20	24	28	35	50	70	85	
	WP + BA	BA	WP											
1/1	10/ 32.8	14/ 45.9	14/ 45.9	23/ 75.5	23.5/ 77.1	24.5/ 80.4	26/ 85.3	28/ 91.9	29/ 95.1	31.5/ 103.3	34.5/ 113.2	37/ 121.4	38/ 124.7	
1/2	7.1/ 23.3	9.9/ 32.5	9.9/ 32.5	16.3/ 53.5	17/ 55.8	17.7/ 58.1	18.7/ 61.4	19.8/ 65	20.5/ 67.3	21.9/ 71.8	24/ 78.7	26.2/ 86	26.9/ 88.3	
1/4	5/ 16.4	7/ 23	7/ 23	11.5/ 37.7	12/ 39.4	12.5/ 41	13.3/ 43.6	14/ 45.9	14.5/ 47.6	15.5/ 50.9	17/ 55.8	18.5/ 60.7	19/ 62.3	
1/8	3.5/ 11.5	4.9/ 16.1	4.9/ 16.1	8.1/ 26.6	8.5/ 27.9	8.8/ 28.9	9.4/ 30.8	9.9/ 32.5	10.3/ 33.8	11/ 36.1	12/ 39.4	13.1/ 43	13.4/ 44	
1/16	2.5/ 8.2	3.5/ 11.5	3.5/ 11.5	5.8/ 19	6/ 19.7	6.3/ 20.7	6.6/ 21.7	7/ 23	7.3/ 23.9	7.8/ 25.6	8.5/ 27.9	9.3/ 30.5	9.5/ 31.2	
1/32	1.8/ 5.9	2.5/ 8.2	2.5/ 8.2	4.1/ 13.5	4.2/ 13.8	4.4/ 14.4	4.7/ 15.4	4.9/ 16.1	5.1/ 16.7	5.5/ 18	6/ 19.7	6.5/ 21.3	6.7/ 22	
1/64	1.3/ 4.3	1.8/ 5.9	1.8/ 5.9	2.9/ 9.5	3/ 9.8	3.1/ 10.2	3.3/ 10.8	3.5/ 11.5	3.6/ 11.8	3.9/ 12.8	4.3/ 14.1	4.6/ 15.1	4.8/ 15.7	
1/128	0.9/ 3	1.2/ 3.9	1.2/ 3.9	2/ 6.6	2.1/ 6.9	2.2/ 7.2	2.3/ 7.5	2.5/ 8.2	2.6/ 8.5	2.7/ 8.9	3/ 9.8	3.3/ 10.8	3.4/ 11.2	

BA: With the Nikon diffusion dome attached.
WP: With the built-in wide panel in place.

SB-700 Guide Number Table (in FX Format)

Standard Illumination Pattern at ISO 100 (m/ft)

Flash Output Level	14			Zoom head position (mm)							
	WP + BA	BA	WP	24	28	35	50	70	85	105	120
1/1	10/ 32.8	14/ 45.9	14/ 45.9	23/ 75.5	25/ 82	28/ 91.9	31/ 101.7	34/ 111.5	35.5/ 116.5	37/ 121.4	38/ 124.7
1/2	7.1/ 23.3	9.9/ 32.5	9.9/ 32.5	16.3/ 53.5	17.7/ 58.1	19.8/ 65	21.9/ 71.8	24/ 78.7	25.1/ 82.3	26.2/ 86	26.9/ 88.3
1/4	5/ 16.4	7/ 23	7/ 23	11.5/ 37.7	12.5/ 41	14/ 45.9	15.5/ 50.9	17/ 55.8	17.8/ 58.4	18.5/ 60.7	19/ 62.3
1/8	3.5/ 11.5	4.9/ 16.1	4.9/ 16.1	8.1/ 26.6	8.8/ 28.9	9.9/ 32.5	11/ 36.1	12/ 39.4	12.6/ 41.3	13.1/ 43	13.4/ 44
1/16	2.5/ 8.2	3.5/ 11.5	3.5/ 11.5	5.8/ 19	6.3/ 20.7	7/ 23	7.8/ 25.6	8.5/ 27.9	8.9/ 29.2	9.3/ 30.5	9.5/ 31.2
1/32	1.8/ 5.9	2.5/ 8.2	2.5/ 8.2	4.1/ 13.5	4.4/ 14.4	4.9/ 16.1	5.5/ 18	6/ 19.7	6.3/ 20.7	6.5/ 21.3	6.7/ 22
1/64	1.3/ 4.3	1.8/ 5.9	1.8/ 5.9	2.9/ 9.5	3.1/ 10.2	3.5/ 11.5	3.9/ 12.8	4.3/ 14.1	4.4/ 14.4	4.6/ 15.1	4.8/ 15.7
1/128	0.9/ 3	1.2/ 3.9	1.2/ 3.9	2/ 6.6	2.2/ 7.2	2.5/ 8.2	2.7/ 8.9	3/ 9.8	3.1/ 10.2	3.3/ 10.8	3.4/ 11.2

BA: With the Nikon diffusion dome attached.
WP: With the built-in wide panel in place.

To find the GN for a different ISO setting, just multiply it by the following factors:

1.4 for ISO 200	4 for ISO 1600
2 for ISO 400	5.6 for ISO 3200
2.8 for ISO 800	8 for ISO 6400

Something you should immediately notice is the factors you multiply the guide number by are the same as the 1-stop intervals for apertures.

FLASH SHOOTING MODES

Manual Mode. When working in the manual flash mode, you choose the flash power output and the aperture. You are completely in control of what the outcome will be. The power levels on the Nikon Speedlights range from $^1/_1$ (full power) to $^1/_{128}$ power.

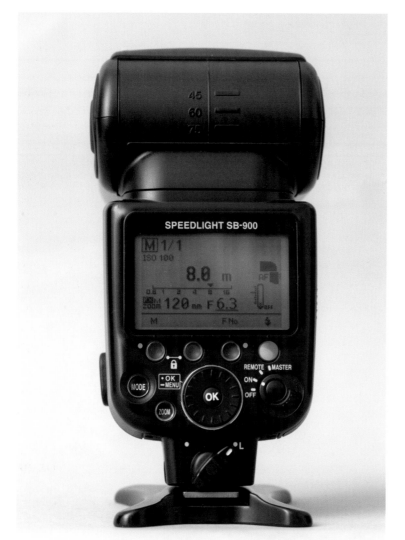

The back of a Speedlight in manual mode.

I chose manual flash for this photograph because I had my flashes set up on stands at a fixed distance from the group. I could repeat the same exposure over and over again no matter how the group size changed because my settings and flash distance from the subjects stayed the same. (f/5.6, $^1/_{60}$ second, ISO 200)

With less advanced flashes, you would need to know your guide numbers or have a light meter to determine your aperture for a proper exposure. With the Nikon Speedlights, once you have your aperture, ISO, and zoom position set, the display on the back of the flash will give you the distance your subject needs to be from the flash for a proper exposure. As you adjust the power level, change your aperture, or zoom your lens, the display will show you how the distance has changed.

The main benefit of manual flash is that you are guaranteed a repeatable flash output from frame to frame. This can be very useful when you are working with a subject that will always be a set distance from the flash, like when creating product shots in a studio. You can also use manual flash when you know that the subject is going to pass through a preset area. This way you know that the flash will be consistent every time; a change in composition will not cause an incorrect flash exposure—something that can occasionally happen in i-TTL or automatic modes.

GN Distance-Priority Manual Mode. The GN distance-priority manual mode is a semi-automatic mode that determines your flash power output when you set your aperture and calculate the distance of your flash from your subject. (This mode only works when the flash is in the horizontal/front down or non-bounce position. The flash also needs to be on-camera or connected by a TTL cord.)

Once you have set your flash-to-subject distance on the Speedlight, you can adjust your aperture and the flash will make the necessary adjustments to its power output. You can select several aperture choices for a particular distance, but the Speedlight remains in manual mode so there is no difference in exposure, a problem that could occur in a more automatic mode when photographing reflective objects or changing the lens focal length.

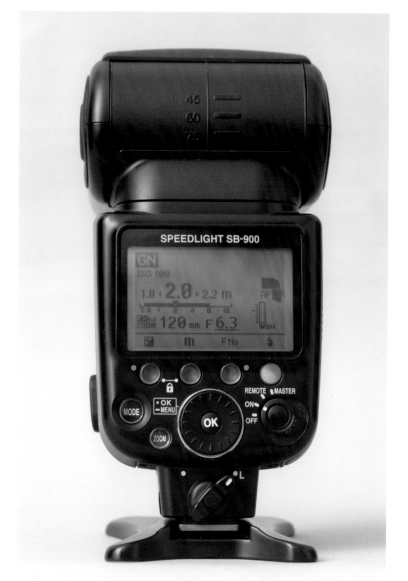

The back of a Speedlight in GN distance-priority manual mode.

This mode is useful when working with Micro-Nikkor lenses for extreme close-up photography. It's also useful when you know that the subject will always be at a certain distance from your flash—but you might want some freedom to change your aperture.

These images were taken in the GN distance-priority mode. Because I knew my flash would remain at a set distance from my subject, choosing this mode allowed me to adjust my aperture as needed for the photographs. (To be completely honest, I find manual mode to be a much more practical mode for most applications.)

APERTURE F/5.6

APERTURE F/22

Non-TTL Auto-Flash/Auto-Aperture Mode. The non-TTL auto-flash/auto-aperture mode uses a built-in sensor on the flash to measure the flash illumination reflected from the subject. It combines the information from the sensor with information communicated from the camera to determine the flash exposure. (*Note:* In auto-aperture mode, the camera communicates the aperture with the flash for a proper exposure. In auto-flash mode, the aperture information is not communicated with the flash; it must be entered on the flash for proper exposure.) Once the sensor has determined that there is enough light to make a proper exposure, it stops the flash from firing.

The non-TTL auto-flash/auto-aperture mode offers the option of firing a series of pre-flashes immediately before the main flash. These pre-flashes help achieve a more accurate flash exposure. (Pre-flashes can be turned off by using the custom settings.)

The back of a Speedlight in non-TTL auto-flash/auto-aperture mode.

A photo taken in non-TTL auto-aperture mode. (f/2.8, $^1/_{60}$ second, ISO 800)

Because the flash exposure is determined by a sensor on the flash and not TTL (through-the-lens) metering, this mode can be a bit more accurate in certain circumstances. If you are changing the composition of a scene that contains a large tonal range (like a bride in a white dress and a groom in a black tux), you might be less likely to see a variation in flash exposure from frame to frame if you choose the auto-aperture mode. (Another way to deal with flash exposure variation is to use the flash value lock, discussed later in this chapter.) However, if you are shooting with a telephoto lens in auto-aperture mode, underexposure may occur even if the subject is within the Speedlight's shooting distance range—the distance at which the flash is still effective. This is where the power of the i-TTL mode is superior.

i-TTL Mode/i-TTL BL Mode (Balanced Fill Flash Mode).
Nikon's i-TTL is the most automated and the most advanced of the flash modes. It works by evaluating the flash exposure and then setting the Speedlight to the proper power level.

The original TTL (through-the-lens) metering worked by measuring the light entering through the lens and reflecting off of the film plane during the actual exposure. The flash was turned off once enough light was received. Since light doesn't reflect off a digital sensor the same way that it does off of film, the Nikon system now uses pre-flashes to help determine the proper exposure. They call this "intelligent" TTL or i-TTL.

These pre-flashes are fired almost simultaneously with the main flash, which makes them nearly undetectable. The light from the pre-flash is reflected off the subject, travels through the camera's lens, and is measured by the meter in the camera. The camera com-

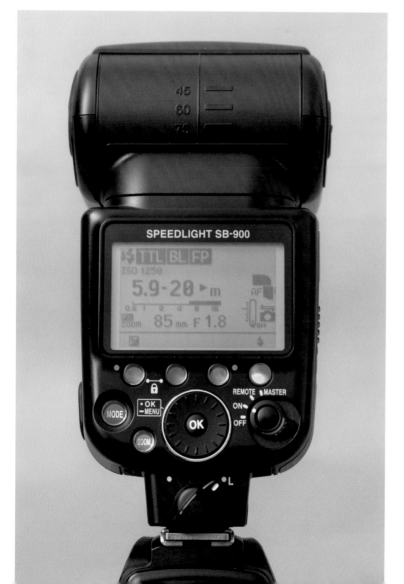

The back of a Speedlight in i-TTL mode.

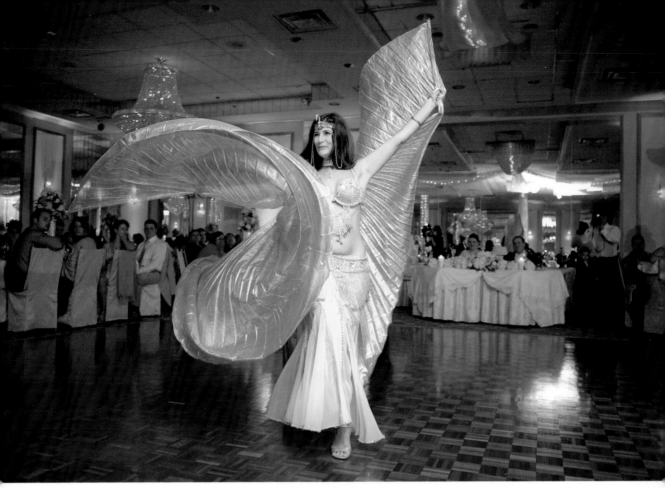

An image taken in i-TTL mode. (f/3.2, $^1/_{80}$ second, ISO 1600)

bines the information from the pre-flash about the scene's available light and shadow areas, subject distance, reflectance, and color temperature with information about the aperture, ISO, and lens focal length to tell the flash at what power it should fire.

Nikon i-TTL has two modes. In standard i-TTL mode the main subject is correctly exposed no matter what the background brightness is. In i-TTL BL mode the flash automatically adjusts the flash output level so that the exposure for the subject and the background are well balanced. (*Note:* Your camera's metering mode must be set to matrix or center-weighted metering for i-TTL BL to work.)

The i-TTL and i-TTL BL modes are useful when you are working in dynamic shooting situations where the distances between the subject and your Speedlights are constantly changing. The technology is so advanced now that it is quicker, and at times more accurate, to let the i-TTL mode determine the flash exposure than to try to calculate it yourself.

Because the flash is sending out pre-flashes and metering them before every exposure, the flash exposure can vary from frame to frame if you change your composition. One way to control this is using the flash exposure lock, discussed later in this chapter.

Repeating Flash Mode. In the repeating flash mode, the Speedlight fires multiple times during an exposure to create a stroboscopic, multiple-exposure effect. This mode is often used with fast-moving objects.

Since you will be using longer shutter speeds to create the multiple flash exposures, it is generally best to work in dimly lit locations so the ambient light does not affect the overall exposure or cause ghosting. Because you will be working at slower shutter speeds to capture multiple flash pops in a single frame, shooting from a tripod is highly recommended. It is also important to use fresh batteries and leave enough time for the flash to fully recycle between images shot in the repeating flash mode.

The back of a Speedlight in repeating flash mode.

To use the mode properly, you need to know the following information:

Frequency (Hz) = The number of times the flash fires per second.

Flash Output Level = The repeating output level at which the flash fires. The output is consistent and the same as using your Speedlight in manual mode.

Times = The number of times you want to fire the flash during one exposure.

Using an SB-900, to get the right exposure for the frame (and the right number of repeating flashes for the effect you want) you will have to consult the table below, which shows the frequency and the maximum number of flashes you can have repeating at any

MAXIMUM NUMBER OF REPEATING FLASHES PER FRAME

Frequency	Flash Output Level												
	M1/8	M1/8-1/3EV	M1/8-2/3EV	M1/16	M1/16-1/3EV	M1/16-2/3EV	M1/32	M1/32-1/3EV	M1/32-2/3EV	M1/64	M1/64-1/3EV	M1/64-2/3EV	M1/128
1Hz 2Hz	14	16	22	30	36	46	60	68	78	90	90	90	90
3Hz	12	14	18	30	36	46	60	68	78	90	90	90	90
4Hz	10	12	14	20	24	30	50	56	64	80	8	80	80
5Hz	8	10	12	20	24	30	40	44	52	70	70	70	70
6Hz	6	7	10	20	24	30	32	36	40	56	56	56	56
7Hz	6	7	10	20	24	26	28	32	36	44	44	44	44
8Hz	5	6	8	10	12	14	24	26	30	36	36	36	36
9Hz	5	6	8	10	12	14	22	24	28	32	32	32	32
10Hz	4	5	6	8	9	10	20	22	26	28	28	28	28
20Hz 30Hz 40Hz 50Hz 60Hz 70Hz 80Hz 90Hz 100Hz	4	5	6	8	9	10	12	14	18	24	24	24	24

given power level. If you want a lot of flash exposures in one frame, you will use a lower power output. This is where it is imperative to know how to calculate the aperture from a guide number.

To create an image in the repeating flash mode, set the camera's exposure mode to manual. Press function button 1 and rotate the selector dial to set the flash output level. Press the OK button. Then, press function button 2 and rotate the selector dial to set the number of flashes (how many times the flash will fire). Press the OK button. Press function button 3 and rotate the selector dial to select the frequency (how many times the flash fires per second). Press the OK button.

Next, you need to calculate the correct aperture and set it on the camera. To do this, look up the guide number indicated by the flash output level and zoom position. Once you have the GN, divide it by the distance of your Speedlight to the subject to get your aperture ($GN/D = A$). (*Note:* The calculated exposure is for the first flash in the sequence. Repeating flash at that output level on an image that overlaps will cause overexposure. You might have to set a smaller aperture on the camera to compensate for this.)

Set the shutter speed on the camera. You determine the shutter speed by dividing the number of flashes by the frequency of flashes (shutter speed = number of flashes/frequency of flashes). This is the fastest shutter speed you can have; if your shutter speed is faster, the flash will not have time to fire all of the programmed flashes. For example: 12 flashes/4 Hz = 3 seconds. The shutter speed must be 3 seconds or more to get all twelve flashes in the frame.

Once you've composed the photo, confirm that the ready light is on and press the shutter.

I find that you'll achieve the best results when photographing subjects that are moving parallel to the camera. There are two reasons for this. First, the repeating flash mode uses manual flash, so the proper exposure is determined by the subject's distance to the flash and the aperture. If the subject is moving toward or away from the camera, the flash must be moved to maintain the same distance from the subject. Otherwise, for part of the frame, your subject will be either underexposed or overexposed. Second, if the

FACING PAGE—Getting the perfect repeating flash photograph takes a great deal of patience. I'm still working on creating one. For the image on the bottom, I was working with repeating flash in a studio apartment and the long exposure meant that the background became visible in the image. It's the reason that you see a ghosting effect. Here's my advice to anyone new to this technique: make sure you work in a very dark environment. You can either work outdoors where you have no background or against a black background to prevent ghosting. If you are working with multiple flashes, be sure to flag them so that no light spills onto your background. (f/11, 3 seconds, ISO 100)

ORIGINAL, PROPERLY EXPOSED
WITH I-TTL FLASH

WITHOUT FLASH VALUE LOCK

moving object stays in mostly one place in the frame, the multiple images will layer up on each other, causing overexposure and a photograph that usually isn't as visually interesting.

SU-4 Mode. The SU-4 mode is a great feature on both the SB-900 and SB-700. It is basically a built-in optical remote that allows your Speedlight to be triggered optically by any other flash—even a non-CLS compatible flash.

Once in SU-4 mode, the flash can fire in either manual or automatic mode. The remote eye is on the side of the flash, right next to the battery door. For the flash to fire, the remote eye needs to be pointed toward the triggering flash. It's best to start by making sure the triggering flash can see the remote eye and then rotate your flash head as needed to light your subject.

Any source of flash will set off the remote speedlight—and that includes pre-flashes. Because the pre-flashes in auto and i-TTL mode happen milliseconds before the actual flash, that doesn't give the remote SU-4 enough time to recycle and contribute to a proper exposure. Therefore, you must make sure that the pre-flashes of your triggering flash are turned off when using the SU-4 mode. You will want the triggering flashes set either to the auto mode without pre-flashes or to the manual mode.

WITH FLASH VALUE LOCK

In the first image (far left), Meredith was properly exposed using i-TTL. But as soon as I changed my composition and focal length, i-TTL made a different value judgment for the amount of flash power it should output. The result is seen in the second image (center). By using the FV lock, I ensured that the flash would continue to output the same amount of flash no matter how my composition or focal length changed, as seen in the final image (immediate left). (f/4, $^1/_{100}$ second, ISO 400)

Because the SU-4 enabled speedlight is triggered by any flash, even the flash of a point-and-shoot camera, it is not the ideal mode to use when working around other photographers who are using flash. If you are shooting in those circumstances, moving over to AWL (advanced wireless lighting) has many benefits.

Flash Value Lock. The flash value (FV) lock feature allows you to maintain the same flash exposure for your main subject throughout a series of photographs. So even if you zoom in on a subject, change your composition, or adjust the aperture, the flash exposure will stay the same.

You will need to program your camera's custom function button to use the FV lock. (See your camera's manual on how to do this.) To activate it, point the camera at your subject and press the function button you just programmed. This will fire pre-flashes to determine a proper exposure for your subject. The flash will lock in the exposure and the flash value will remain the same until the FV lock's function button is pressed a second time.

FV lock is only available with i-TTL or auto-aperture flash control. It can be used with multiple flashes, AWL, and auto FP high-speed sync (covered later in this chapter).

FLASH EXPOSURE COMPENSATION

Flash exposure compensation (FEC) is valuable when working in any of the automatic flash modes (auto or TTL), where the flash or camera's meter determines how much output the Speedlight should give. You can adjust your exposure compensation on the camera or directly on the flash.

As we discussed earlier, all meters try to expose the scene to a middle gray tone. While this is fine for a scene that contains a complete tonal range, you will run into exposure problems when using an automatic mode to photograph a scene or subject that is dominated by dark or light tones. To compensate for this, you can use the flash exposure compensation (FEC) to increase or decrease the flash output. The flash exposure compensation value for Nikon runs between −3 EV and +3 EV. This is 3 stops below and 3 stops above the metered flash output, for a 6 stop range.

FACING PAGE—Since Jenny was dressed in black and standing in a dark room, the camera's meter wanted to overexpose the scene. Notice the difference achieved by dialing down the FEC by 1, 2, and 3 stops. (f/5.6, $^1/_{125}$ second, ISO 400)

Flash exposure compensation set on the back of a Speedlight.

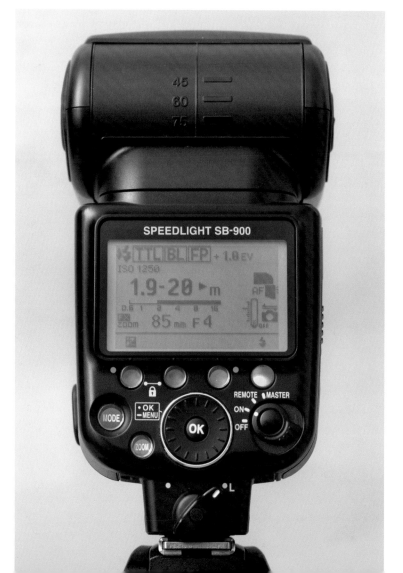

FEC 0EV

FEC −1EV

FEC −2EV

FEC −3EV

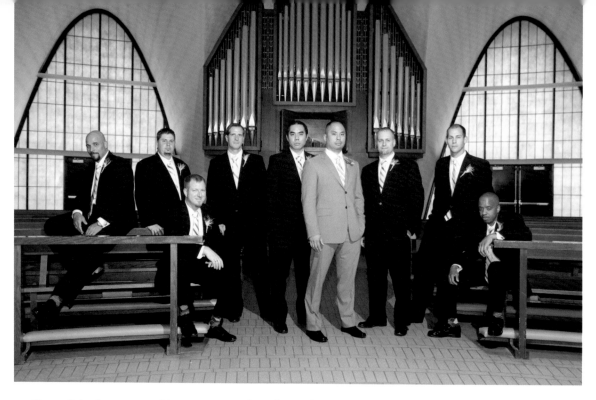

One of the important things to remember about the Nikon system is that exposure compensation on the camera body controls both the flash exposure *and* the ambient light. (See your camera manual on how to adjust exposure compensation on the camera body.) With flash as your main source of light, if you increase the exposure compensation on your flash by 2 stops (+2 EV) and reduce it by 2 stops on-camera (–2 EV), the settings will basically cancel each other out.

While it might seem counterintuitive at first, it is important to keep two guidelines in mind when using FEC:

1. **If your scene is composed of mostly light tones, like a bride in white or snow, increase (+) your FEC.** (The camera will see the white tones and want to underexpose them to get a middle gray tone, so you'll want more flash output to properly expose the photograph.)

2. **If your scene is composed of mostly dark tones, like a man in a tuxedo in a dark room, decrease (–) your FEC.** (The camera will see the dark tones and want to overexpose them to get a middle gray tone, so you'll want less flash output to properly expose the photograph.)

ABOVE—I pay close attention to the FEC when photographing the groomsmen at a wedding. All the black tuxedos make the camera think that it needs to tell the flash to put out a lot more power than is actually needed to get a proper exposure. I will often reduce my flash output by reducing the FEC by 1 or 2 stops to get the perfect exposure. (f/4, $^1/_{125}$ second, ISO 800)

FACING PAGE—To compensate for the white snow and the white dress in i-TTL, I increased my FEC by +1.3EV for the main light, an SB-900 in a softbox. A second unmodified SB-900 in i-TTL mode was used as a kicker from camera left. (f/8, $^1/_{320}$ second, ISO 100)

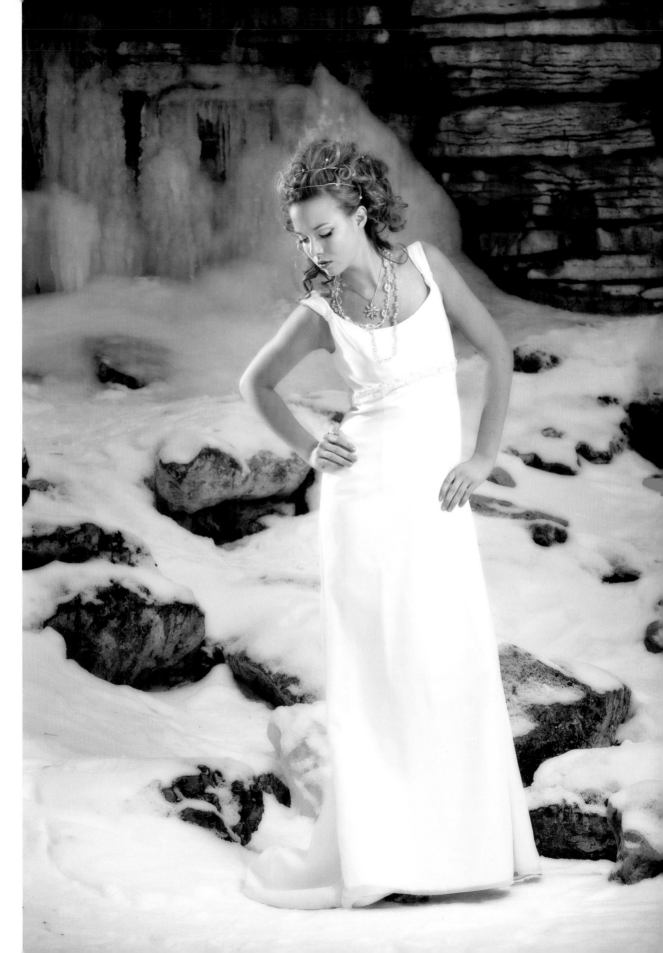

These photographs were taken with direct on-camera flash. **LEFT**—TTL-BL did a good job of balancing the ambient light with the flash on Meredith to give me a subtle level of fill flash. **RIGHT**—The i-TTL mode actually overexposed my subject.

LEFT—By dialing the i-TTL down by 1 stop (–1EV) I got this exposure, which is closer to the TTL-BL setting. **RIGHT**—I got what I think is a very pleasing fill flash level by dialing down the FEC to –2EV in this circumstance. Remember, however, that each situation is a bit different and you will need to adjust your FEC accordingly. (f/2.8, $^1/_{160}$ second, ISO 400)

There is no set standard of how much you will need to increase or decrease the FEC for a particular scene. There are many factors that will determine how much change is needed. These include:

1. The tone and reflectivity of your subject.
2. How much of your frame is filled by the subject.
3. The subject's distance from the background.
4. The available light.
5. Backlighting. (You will generally need more exposure compensation in backlit circumstances.)
6. Composition (*i.e.*, whether your subject is off-center or not).

Flash Exposure Compensation and Fill Flash. When you're working outside and you want to add just a touch of fill flash to lift the shadows, flash exposure compensation is an excellent means to do so. You will generally lower your FEC to somewhere between –1EV and –3EV. But once again, the exact value depends on the available light circumstances and the tonality of your subject.

Flash Exposure Compensation and TTL-BL Mode. When working in TTL-BL mode, the flash takes into consideration the available light and adjusts the flash output so that it balances better with the available light. You may still want to reduce your FEC, but you will generally have to do it less when using TTL-BL for fill flash.

So why not shoot in TTL-BL all the time? As we can see from the photos on the facing page, TTL-BL did a better job of balancing the ambient light with the light from the Speedlight. However, I have found that when bouncing my flash off a wall or ceiling to provide light, the photograph can be a bit underexposed and it is best to use the i-TTL mode. (For more on bounced flash, see chapter 5.)

Between the TTL-BL mode (left) and the i-TTL mode (right), you can see almost a $^1/_2$ stop difference in the result achieved by bouncing the light off the wall and ceiling to the left of the camera. (f/4, $^1/_{100}$ second, ISO 1600)

CUSTOM FUNCTIONS

The SB-900 and SB-700 flashes have menu features that allow you to customize how your flash functions. Below is a list of the functions and how they affect the Speedlight's performance.

SB-900 CUSTOM FUNCTIONS

To display the custom function menu, press the OK button for approximately one second. Rotate the selector dial to choose the custom function you want to change. Press the OK button again. Rotate the selector dial to highlight the setting you want and press the OK button to set it. Press function button 1 (it says exit on the LCD screen) to leave the menu and return to the normal display.

\boxed{A} **Non-TTL Auto Flash Mode.** Information on this appears earlier in the chapter.

$\boxed{⚡☉A}$ Auto Aperture Flash (with modeling illumination; this is the default)

$\boxed{☉A}$ Auto Aperture Flash (without modeling illumination)

$\boxed{⚡A}$ Non-TTL Auto Flash (with modeling illumination)

\boxed{A} Non-TTL Auto Flash (without modeling illumination)

$\boxed{⤺APT}$ **Repeating Flash Setting of Master Flash Unit.** By turning this function on, you allow the SB-900 to control multiple remote Speedlights in the repeating flash mode.

\boxed{M} **Flash Output Level at Manual Mode.** Setting this function to on allows you to adjust the output level in manual mode between $1/1$ (full) and half power in $1/3$ EV steps. The default setting has this func-

tion turned off so there is a full EV step between full and half power.

$\boxed{SU-4}$ **SU-4 Type Wireless Multiple Flash Shooting.** Activating this function puts the flash into SU-4 mode in both master and remote settings. It disables the CLS and pre-flashes. The flash operates as a simple optical slave or remote.

$\boxed{◢}$ **Illumination Pattern.** This allows you to choose your illumination pattern and how much light fall-off you have at the edge of the image frame. You can choose center-weighted (CW), standard (STD), or even (EVEN) illumination. (More on this later in the chapter.)

$\boxed{◼/⚡}$ **Test Firing Button.** There are two options for the function of your test firing button: flash and modeling.

\boxed{FLASH} Pressing the flash button will cause the flash to fire a single pop. This is the default setting.

$\boxed{MODELING}$ Pressing the modeling button will cause a continuous series of flashes for about 1.5 seconds. Acting like a modeling lamp on a studio strobe, this allows you to see the effect the flash will have on your subject and check the lighting patterns and shadows.

$\boxed{FLASH⚡}$ **Flash Output Level of Test Firing in i-TTL Mode.** This determines the output level of the test fire when the Speedlight is set to the i-TTL mode. You can choose between $1/128$ power (the default), $1/32$ power, or $1/1$ (full) power. (*Note:* When the flash is set to the auto or manual modes, it will fire at the selected settings.)

FX/DX **FX/DX Selection.** The default setting for this function is for the flash to detect automatically whether it is attached to a FX- or DX-format camera. The flash will automatically change the light distribution angle based on the camera's image area between the FX and DX format. This saves power by making sure that the light from the Speedlight is used in the most efficient manner. The custom function allows you to disable the automatic function and manually set the Speedlight to FX or DX.

zoom M **Power Zoom Off.** The Speedlight has an automatic zoom function that adjusts the flash head to match the focal length of your lens. By turning this function to "on" you are turning *off* the power zoom. The default setting is to have this custom function off; this means that the flash will automatically power zoom.

AF **AF-Assist Illuminator/Flash Firing Off.** The AF-assist Illuminator uses red LEDs to project a lighting pattern onto the subject. This helps give the scene some contrast that the camera's autofocus can lock onto in low-light situations. This function can be set to on (default) or off. It also has an AF ONLY function. This means that only the AF-assist fires and the flash is restricted from firing.

STBY **Standby Function.** This allows you to adjust the time that the Speedlight stands idle before it goes into sleep mode. You can set it to a specific time or use the default auto setting that turns off the Speedlight when the camera's exposure meter turns off. The standby function can also be disabled altogether. To wake up the flash again, gently tap the shutter button.

ISO **ISO Sensitivity.** This allows you to manually adjust the ISO setting on the flash. With older film cameras, this needs to be adjusted manually. Current cameras communicate the ISO information directly to the flash.

READY **Ready-Light Setting on Remote Flash Units.** When the flash is set up as a remote there are three options to tell if the flash is ready to fire. With the rear/front option, you can have the two LEDs in front blink and the red ready light on the back turned on (this is the default setting). Alternately, you can choose to have just the LEDs in front blink (the front option) or just the rear ready light be lit (the rear option).

LIGHT **LCD Panel Illuminator.** This allows you to adjust the LCD panel brightness.

Thermal Cut-Out. The SB-900 has a thermal cut-out feature that prevents the flash from firing when it gets too hot from quickly firing multiple times. This prevents the flash from overheating and destroying the head. The flash will not fire again until the unit cools down. While this feature is very useful in preserving the life of your flash, it can shut down your flash at the most inopportune times. The default setting is to have the thermal cut-out on. This function allows you to turn it off.

| ♪ | **Sound Monitor.** The SB-900 has a sound monitor that indicates its status when it is used as a remote. The default setting is to have it on. You can turn the sound monitor off for silent operation. One beep indicates the Speedlight is charged and ready to fire at full power. Two short beeps indicate that the flash fired properly. Three long beeps indicate that the flash did fire at full power but there might not have been enough output to properly expose the subject.

| LCD ◐ | **LCD Panel Contrast.** This allows you to change the contrast of the LCD panel to make it easier to view in bright light situations.

| m/ft | **Unit of Measuring Distance.** This allows you to view the distance settings on the Speedlight in either feet or meters.

| WP ◣ | **Zoom Position Setting.** If the built-in wide-flash adaptor is broken off accidentally, the automatic power zoom function is disabled and the Speedlight stays at the widest zoom setting. If that situation arises, turning this function on will allow the flash to once again automatically set the zoom position.

| ☑ | **"My Menu" Setting.** This function allows you to see either all of the custom function settings in the menu, or just the select ones that you change most often. The default setting is to see the full menu.

| VER. | **Version of Firmware.** This shows the firmware version. The SB-900 firmware can be updated by connecting the Speedlight to a compatible camera. See the Speedlight manual or camera manual for compatibility.

| RESET | **Reset Custom Setting.** This resets all of your settings back to the factory default settings.

SB-700 CUSTOM FUNCTIONS

To display the custom functions menu, press the menu button. Rotate the selector dial to choose the custom function you want to change. Then, press the OK button. Rotate the selector dial to highlight the setting you want and press OK to set it. Press the menu button to return to the normal display. The feature descriptions are the same as the SB-900 unless noted.

| ◣ FILTER | **Color Filters.** You can manually set the color of the filter being used on the SB-700 to red, blue, yellow, amber, or other (for when the filter color is something other than the four colors listed).

| ◣ REMOTE | **Remote Flash Unit Setting.** Activating this puts the flash in SU-4-type wireless-flash mode. The SB-700 can only be used as a remote unit in SU-4 mode.

| ♪ | **Sound Monitor**

| LCD ◐ | **LCD Panel Contrast**

| STBY ○ | **Standby Function**

| FX/DX | **FX/DX Format Selection**

| M ↨ | **Flash Compensation Step in Manual Flash Mode**

| m/ft | **Unit of Measuring Distance**

| AF ◣ | **AF-Assist Illumination.** The SB-700 does not have the AF-assist-only mode.

| VER. | **Version of Firmware**

| RESET | **Reset Custom Setting**

FLASH SYNC MODES

The flash sync modes determine at what point during the movement of the shutter curtains your camera fires the flash. There are four main flash sync modes: first curtain; second curtain/rear sync; slow sync; and high-speed sync. Before we get into explaining the flash sync modes, we want to have a good understanding of shutter speeds and the maximum flash sync speed.

Shutter Speeds. The shutter of a modern DSLR camera is made up of two metal curtains. When you press the shutter button, the first curtain opens to expose the sensor to light. The second curtain then follows the first curtain and closes to end the exposure. The time between the opening of the first curtain and the closing of the second curtain is the shutter speed.

For some shutter speeds, the first curtain is completely open before the second curtain starts to close. At higher shutter speeds, the second curtain starts to close before the first one is fully open. This means that you basically have an open slit moving across the sensor. At very high shutter speeds, the space between the first and second curtain is a very narrow slit.

Maximum Flash Sync Speed. The maximum flash sync speed is the fastest shutter speed at which the first curtain is completely open before the second curtain starts to close, meaning that the entire sensor is exposed to light, edge to edge, at the exact same time. This is extremely important in flash photography. The flash is a single instantaneous burst of light and the entire sensor must be exposed at once to be fully exposed. If

The shutter curtain traveling and flash burst for normal sync.

LEFT—A flash photograph shot at the maximum flash sync speed ($^1/_{250}$ second).

RIGHT—This photo, shot at $^1/_{400}$ second, demonstrates what happens when you exceed the maximum flash sync speed.

you take a flash photograph at any shutter speed faster than the maximum flash sync speed, the curtain will block some of the sensor—appearing as a dark (underexposed) bar in the photograph. (*Note:* You can freely use your flash at any shutter speed slower than the maximum flash sync speed, but you will need to take into consideration the ambient light levels for proper exposure.)

The maximum flash sync speed for most Nikon cameras is $\frac{1}{250}$ second. When using a Nikon dedicated flash with most Nikon cameras, the camera will not let you set the shutter speed above the maximum flash sync speed (unless you are in auto FP high-speed sync mode), so you won't have to worry about a black underexposed bar from the shutter curtains showing up on your images.

Front (First) and Rear (Second) Curtain Flash Sync. When you are dealing with slower shutter speeds, you have to remember that you are recording light not only from the flash but also from any ambient light sources. If the object is static, it will make little difference as to when the flash fires. However, if the object is in motion, in addition to the motion-freezing light from the flash, the ambient light will record blur on a fast-moving object. This blurry trail is called ghosting. By placing the flash burst at either the beginning or the end of the exposure, you can control where the ghosting appears. (This is set from your camera body. See your camera's manual for specific instructions on how to set these modes.)

First curtain (or front curtain) sync is the default setting for the Nikon Speedlights and works well for most applications. In this mode, the flash will fire as soon as the first curtain is completely open and the sensor is completely exposed. In first curtain sync, the flash freezes the object at the beginning of the ambient exposure. Because the object is still moving, the ambient light records as a blur in front of the object. This can

Front curtain sync (f/4, $\frac{1}{10}$ second, ISO 1600)

Rear curtain sync (f/4, $\frac{1}{10}$ second, ISO 1600)

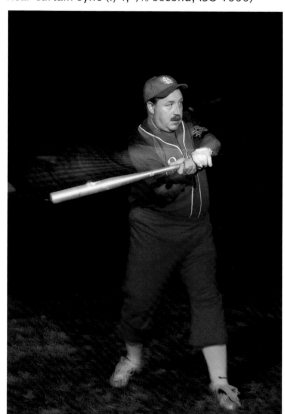

give it the impression that the object is moving backwards. The way to combat this is to use second curtain (or rear curtain) sync.

Like its name suggests, second curtain sync has the flash firing just before the second curtain closes. This means that the ambient light that is recorded on the moving subject will appear behind the subject. This gives a much more accurate sense of movement.

It should be noted that choosing between first and second curtain sync only affects *when* the Speedlight fires, not the actual flash exposure.

Slow-Speed Sync. When your camera—not your flash—is working in manual mode, you can simply choose a shutter speed that is long enough to record the ambient light in the background. However, when you are working in your camera's aperture priority or program mode, the camera detects a flash and will default to a sync speed that allows you to hand-hold the camera without camera shake. Usually, that's about $^1/_{60}$ second; this can be adjusted in the camera's custom menu. But if you are photographing at night and you want more ambient light in your images, you can switch to the slow-speed sync mode. This does not affect the timing of the flash (like first or second curtain sync), it only slows the shutter speed so that you obtain the correct exposure for both the main subject and the background in low-light situations. You set the slow sync mode on your camera body; consult your camera's manual for how to do this.

Red-Eye Reduction with Slow-Speed Sync. The red-eye effect occurs when light bounces off of the retinas of the eyes. You'll often see this in photos taken in dim light. To reduce the occurrence of red-eye, the flash fires three small

Using second curtain sync with a slow shutter speed at a wedding reception helped convey a lively party with lots of action. Because the flash happens at the end of the exposure, however, you can miss the perfect moment and expression if you're not able to anticipate the action properly. (f/4, $^1/_5$ second, ISO 800)

Sparklers are always fun to play with. I placed my camera on my tripod, set my camera to rear curtain sync, and then asked the couple to play with the sparklers and end with a kiss. The rear curtain sync caught the kiss while the long exposure recorded the ambient light from the moving sparklers. (f/11, 5 seconds, ISO 200)

pre-flashes. The pre-flash causes the subject's pupils to contract, reducing the reflection of light bouncing off the retinas. The red-eye reduction

A photo created without slow sync (f/4, $\frac{1}{60}$ second, ISO 400).

The same scene shot with slow sync (f/4, $\frac{1}{4}$ second, ISO 400).

with slow-speed sync mode combines the three pre-flashes of red-eye reduction with the longer shutter speed of the slow-speed sync mode. This mode is also set on your camera. Consult your camera manual for how to set it.

Auto FP High-Speed Sync. As mentioned previously, it is impossible to get a completely exposed frame when you use a standard flash mode with a shutter speed that exceeds the maximum flash sync speed. There will be times, however, when you will want to use a wider aperture for creative purposes. This, in turn, will require a higher shutter speed for proper exposure. Or, you might need a higher shutter speed than $\frac{1}{250}$ second to completely freeze the action. This is where high-speed sync comes into play. Auto FP high-speed sync (HSS) gives you the opportunity to use your Speedlights in almost any circumstances, opening up a whole new world of creative possibilities.

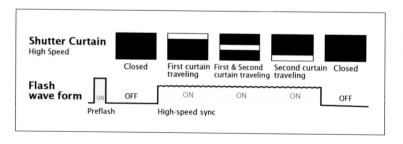

The shutter curtain traveling and flash burst for high-speed sync.

| MANUAL FLASH (F/5.6, 1/250 SEC, ISO 400) | HSS (F/5.6, 1/320 SEC, ISO 400) | HSS (F/2.8, 1/320 SEC, ISO 400) |

In the first photo, the flash was set at normal flash mode in manual at full power. I switched to HSS for the second shot, and you can see the loss of power. It was almost a 2-stop difference, as you can see in the third photo, where I compensated for the power loss by choosing a wider aperture.

Instead of giving one single pop of flash, HSS causes the flash to rapidly pulse multiple times at a slightly lower output during the entire exposure. It basically makes your flash function as a continuous light source, producing light during the entire exposure. As a result, the entire frame is properly exposed with no black bars.

There is an important trade-off to be aware of: in HSS mode, the flash power (or GN) is greatly diminished. This means that your flash-to-subject distance will be reduced. Another issue to

Here, using HSS let me shoot at a wider aperture by allowing a shutter speed that's much faster than the maximum flash-sync speed. (f/4, $\frac{1}{640}$ second, ISO 100)

keep in mind is battery consumption. It takes a lot of energy to rapidly fire your flash in the pulsing HSS mode.

ZOOMING THE FLASH HEAD

The zoom feature of the Speedlight was created so that the flash coverage could closely match the same angle of view as the lens. This allows the Speedlight to spread the light for wider views or to concentrate the power for a greater distance of coverage at longer focal lengths. The SB-900 flash head zooms between 17mm and 200mm. The SB-700 zooms between 24mm and 120mm. This makes your flash much more efficient because the flash is able to place the light only where it's needed.

The flash will automatically detect the focal length of the lens and adjust the flash head accordingly. If you are using a zoom

The back of the flash zoomed to 200mm.

Both of these photos were shot with a 24mm lens and at the same exposure settings. The photo on the left was shot with the flash head at 35mm. For the photo on the right, the flash head was zoomed to 200mm. This created a spotlight effect with a minimal spread of light. (f/2.8, $^1/_{25}$ second, ISO 1000)

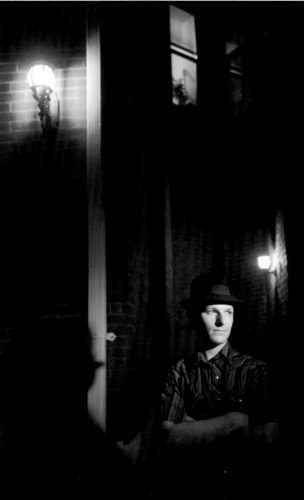

50MM

105MM

200MM

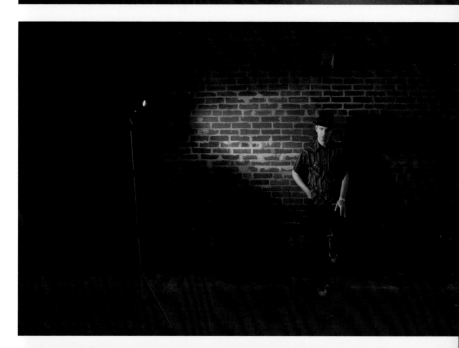

These photos demonstrate the effect of zooming your flash head from 50mm, to 105mm, to 200mm. (f/2.8, $\frac{1}{30}$ second, ISO 1600)

lens, the flash will adjust as you zoom your lens. You can also set the zoom focal length manually for creative purposes. By choosing a narrow spread of light from your Speedlight, for example, you can basically create your own spotlight.

To manually zoom your flash, press the zoom button on the flash. Use the selector dial to adjust the zoom focal length. Hit the OK button to confirm the selection. You can also repeatedly press the zoom button to cycle through the zoom positions.

ILLUMINATION PATTERNS

The Nikon Speedlights offer three illumination patterns that each give a different light fall-off at the image edges. This means that you can choose the illumination pattern that best fits your subject and shooting style.

The three illumination patterns are standard, center-weighted, and even. For the SB-900, the illumination pattern is set in the custom menu. For the SB-700, there is a switch on the side of the Speedlight that lets you choose between the different patterns.

Standard Illumination. This is the default illumination pattern for the Speedlight, and it's good for most subjects. The light fall-off is minimal and less than most typical external flashes—though it may be visible in some circumstances.

THE LIGHT FALL-OFF IS MINIMAL AND LESS THAN MOST TYPICAL EXTERNAL FLASHES . . .

Center-Weighted Illumination. This mode focuses the light of the Speedlight a bit more tightly in the center. This causes the flash to be more powerful at the center point and have a higher GN compared to other illumination patterns at the same focal length. However, it also causes greater light fall-off on the edges. This mode is good for portraits and other subjects where light fall-off at the edges of the frame is not critical.

Even Illumination. This mode provides the most even illumination with less light fall-off at the edges than standard illumination. This mode is good for group portraits or photos that require well-lit image edges.

4. MODIFIERS AND LIGHTING PATTERNS

MODIFYING YOUR FLASH

As photographers, we need to have a good grasp of how to see the light, create the light, and shape the light that we use in our photographs. There are two main reasons why we want to modify the light from our Speedlight.

1. To diffuse the light by increasing the relative size of the Speedlight
2. To control, direct, or restrict the spread of light from the Speedlight

As we discussed earlier, the larger your light source is in relation to your subject's size, the softer and less defined your shadows will be. This can give your photos a much more pleasing and natural look.

LEFT—Unmodified direct flash.

RIGHT—As a point of reference, this is the look that direct on-camera flash produces.

Portrait shot with an SB-900 in a softbox. (f/3.5, $\frac{1}{60}$ second, ISO 320)

There will also be times when you only want to light certain parts of your image. Some modifiers will direct the light to specific areas and others will prevent the light from spilling all over parts of the scene where you don't want it.

There are a lot of different modifiers available for you to purchase and we will discuss several different types. We will also dis-

cuss a few modifiers that you can quickly and inexpensively make yourself. (*Note:* There are a many different types of modifiers on the market, with new ones being added regularly. It would be impossible to review and show all the different modifiers available today. While there might be a slight difference in light quality between different models of the same type of modifier, the looks they yield should be very similar.)

INCREASING THE SPREAD OF LIGHT

Built-in Wide-Angle Diffusion Panel. The purpose of the wide-angle diffusion panel is to increase the spread of light produced by your flash. It is mostly used when you are working with a wide-angle lens and want to make sure your entire frame is evenly lit by the flash. While it's not as effective as other diffusion modifiers, it does make a difference.

ABOVE—The built-in wide-angle diffusion panel.

RIGHT—The effect of built-in wide-angle diffusion panel.

Dome Diffusers. Both the SB-900 and the SB-700 come with dome diffusers that attach directly to the flash head. These small, rectangular, plastic diffusers are easy to carry and are not too bulky on the flash heads. The purpose of the diffuser is to scatter the light in many different directions so that the light is not directional and the shadows are softer. Many photographers tilt the head of the flash to a 45 degree angle when using the diffusion dome. The idea is that you are able to bounce the flash off the ceiling and walls while still directing some of the light forward. While this does soften the shadows and give more pleasing light than direct, unmodified flash, the light is still fairly flat and non-directional.

In addition to the standard model, there are several other diffusers on the market, including the Lightsphere by Gary Fong and the Globe Diffuser from Interfit Strobies. These light modifiers do a fine job of diffusing the light—but, as you can see by the photos, the size of the modifier itself can be a bit cumbersome at times.

The thing to note when using all of these modifiers is that when the flash is used on-camera and you take a vertical photograph, you tend to have a visible—and in my opinion ugly—side shadow behind the subject.

ABOVE—The Nikon dome diffuser.

LEFT—The effect of the Nikon dome diffuser.

ABOVE—Lightsphere by Gary Fong.

RIGHT—The effect of the Lightsphere by Gary Fong.

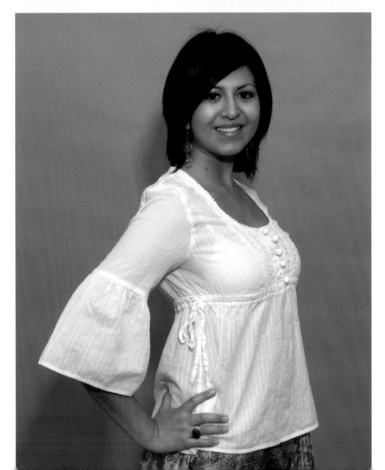

ABOVE—Globe Diffuser by Interfit Strobies.

RIGHT—The effect of the Globe Diffuser by Interfit Strobies.

Bounce Reflectors and Bounce Cards. Bounce reflectors and bounce cards are relatively inexpensive, easy to use, and practically indestructible.

The whole purpose of a bounce card is to give you a surface to bounce the flash off of to spread the light around. When shooting, the flash is pointed upwards at a 90 degree angle. Then, the bounce reflector is attached to the flash so that the light is bounced

LEFT (TOP AND BOTTOM)—The in-flash bounce card and its effect.

RIGHT (TOP AND BOTTOM)—A Honl flag as a bounce card and its effect.

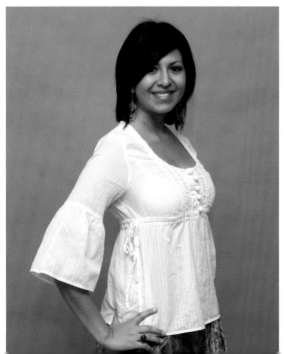

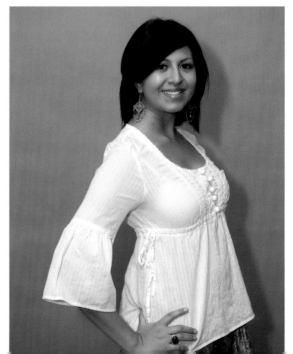

The Rogue Flash Bender as a bounce card and its effect.

The LumiQuest ProMaster Bounce System and its effect. (*Note:* The LumiQuest ProMaster Bounce System does not work properly for on-camera flash in the vertical position since you cannot adjust the modifier. The only way to use it to take vertical photos is to have it mounted on a flash bracket so that the flash stays in the same position but the camera orientation moves.)

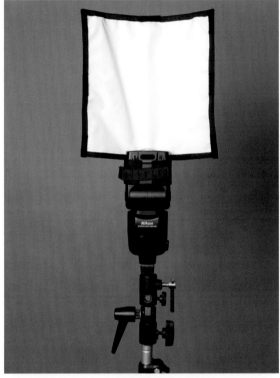

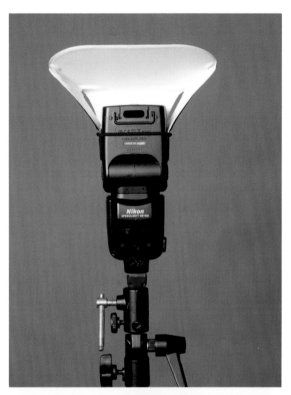

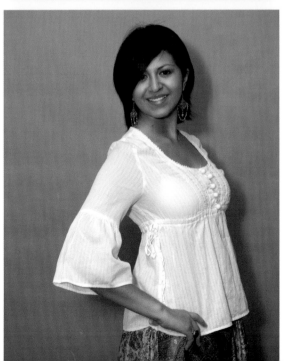

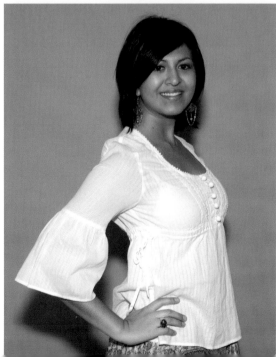

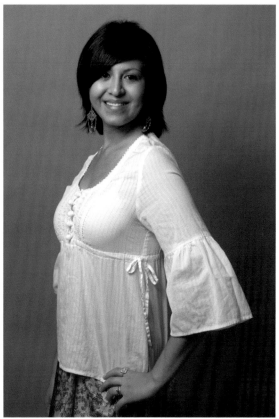

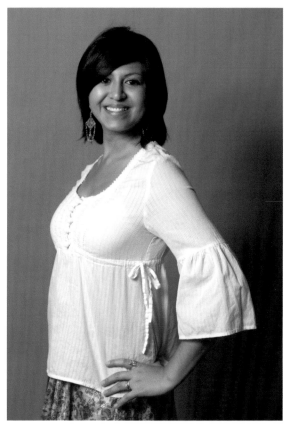

A shoot-through umbrella and its effect.

A convertible/bounce umbrella and its effect.

forward onto the subject. This, of course, is just another way to soften the shadows and make the light look more natural.

In addition to the commercial products, there are a lot of inexpensive materials out there that work well as a bounce card. You can use anything from white craft foam to thick index cards. Simply attach them with a sturdy rubber band and you have a bounce card for under a dollar. In extreme situations, if you don't want to use direct flash and have no surface to bounce off of, you can use your hand behind the Speedlight to bounce light back into the subject. Because of the color of your hand, the bounced light will have a warm glow to it.

Umbrellas. Umbrellas are affordable, easy-to-use modifiers for your flash. There are two types of umbrellas: translucent and reflective. Umbrellas also come in diameters from 30 inches to 72 inches. A larger umbrella will produce softer light and a greater dispersion of light.

To use translucent umbrellas (also known as shoot-through umbrellas) you fire your flash through the white fabric of the umbrella. This both increases the relative size of your Speedlight and causes the light to fall on your subject from many different angles. This makes the lighting effect softer.

Reflective umbrellas bounce light back on your subject from one of three different colored materials on the interior surface: white, gold, or silver. The white interior will produce the softest light while the silver will give it more specularity. The gold will add warmth to the photo. Like shoot-through umbrellas, reflective umbrellas spread the light, but the angle of diffusion is not as great.

Convertible umbrellas let you have the best of both worlds; the black cover of the umbrella is removable, which allows the white interior to become a shoot-through umbrella.

One of the great benefits of working with Speedlights is their light weight and portability. That makes collapsible umbrellas a great addition to any portable studio kit. These double-folding, regular-sized umbrellas (usually around 45 inches) collapse down to less than 15 inches long and easily fit into any case.

One of the limitations of any umbrella is that it does spread the light quite a bit and you have limited control over where it goes. However, that is also a reason why it is a very good modifier to use with large groups.

Softboxes. Like umbrellas, softboxes increase the relative size of your Speedlight to create soft, beautiful lighting. However, softboxes give you much more control over where the light will go. As the name suggests, a softbox is a four-sided black nylon box with reflective material on the inside and diffusion material on the front. There is an opening in the back of the soft box to attach a Speedlight or other light source.

Traditional studio softboxes are held open by metal rods that run through the corners of the box. These metal rods are attached to a speed ring in the back. The flash fires through the speed ring. The only problem with these types of softboxes is that they do take a fair amount of time to set up and tear down. Newer folding softboxes, designed with the on-location Speedlight photographer in mind, are now much easier to set up, tear down, and transport. They fold up like a traditional round reflector panel and fit into a compact carrying case.

Softboxes come in all different sizes. There are some very small softboxes (8x8 inches) on the market that attach directly to your flash. But since you will probably use the Speedlight off-camera, I recommend a larger softbox with a proper speed ring and flash mount. The popular sizes for working with a single Speedlight in a softbox are between 15x15 inches and 24x24 inches.

FACING PAGE—Image shot with an SB-900 in a softbox (f/2.8, $\frac{1}{60}$ second, ISO 1250).

A Lastolite Ezybox softbox and its effect.

An Interfit Strobies softbox and its effect.

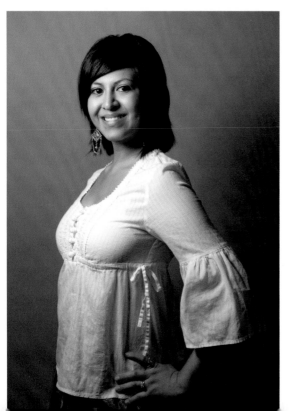

Beauty Dishes. A beauty dish is a parabolic reflector, which is a curved pan that collects and projects the light in a certain direction. The beauty dish is a shallow pan with a hole cut in it to

A 6-inch beauty dish from Interfit Strobies and its effect.

A 15-inch beauty dish from Interfit Strobies and its effect.

The Orbis ring flash and its effect.

mount the Speedlight. A second smaller pan is mounted in front of the Speedlight. Light from the Speedlight bounces off the smaller pan back into the larger main dish and is directed toward the subject.

The nice thing about beauty dishes is that they are highly directional, essentially a step between umbrellas and softboxes. The beauty dish produces light that is diffused but still defined enough that you can direct and feather it as you would with a softbox. Because the light is also focused more than with a softbox, you will see that the edge of the light spread is fairly abrupt.

The ideal distance to place your beauty dish from your subject is generally two times the diameter of the dish.

Ring Flashes. Circular ring flashes, common in macrophotograpy, have gained a great deal of popularity in fashion and portrait photography over the past few years. Not only does the ring flash soften shadows, it also renders the light in a unique way that gives the model a shadowy halo, which is a common feature of fashion photography. Because it doesn't cast a set of directional shadows of its own, it's also a popular way to provide fill light without introducing new shadows to an image.

The Orbis is an attachment that converts your Speedlight into a ring flash. Simply attach the Orbis to your Speedlight, insert your lens through the Orbis and you have a traditional ring flash. You can also use the Orbis off-camera to provide a light source that is larger and softer than direct off-camera flash. You will need to control your off-camera Speedlight by connecting it with a SC-29 TTL remote cord or the Nikon Advanced Wireless Lighting system.

MODIFIERS AND LIGHTING PATTERNS **101**

Diffusion Panels. Diffusion panels are large pieces of semi-transparent material that are stretched over a frame. Placing the panel between your subject and your Speedlight diffuses the light and makes the shadows less defined.

The difference in the quality of light between a softbox and diffusion panel is that the softboxes are capable of creating more even lighting across their front panel—especially when used with the internal baffles. Diffusion panels, on the other hand, can have a hot spot.

Like most modifiers, there are many different options out there. Many collapsible reflector kits come with a diffuser disk. You can also purchase a frame system that provides proper support for a larger diffuser panel. For the do-it-yourself route, a white bed sheet strung between two stands makes a very large and inexpensive diffusion panel. The sheet makes the relative size of the light larger—but as with all diffusion panels, you will probably have issues with hot spots and light fall-off on the edges.

RIGHT—A collapsible diffusion panel in use.

FACING PAGE—The effect of a diffusion panel.

RESTRICTING THE SPREAD OF LIGHT

Built-In Zoom Control. The built-in zoom function of the Speedlight is actually there to help maximize the effectiveness of your zoom lenses. It focuses the light to correspond to the angle of view of your lens. However, choosing a focal length on your Speedlight that is longer than the focal length of the lens will create a spotlight effect with the flash. For example, if your lens focal length is 24mm but your Speedlight is zoomed to 200mm, the spread of light from the flash will be minimal. There will be a great deal of falloff and most of the frame will not be illuminated. (See chapter 3 for some example images.)

A Honl snoot and its effect.

A Rogue Flash Bender and its effect.

Snoots. A snoot is a tube that attaches to the front of the flash and restricts the spread of light coming from the flash head. It is a great tool to use as a spotlight or to direct light in one specific location. The longer the snoot, the more restricted the spread of light will be.

Snoots can be made of all different types of material. Commercial snoots for Speedlights tend to be made out of a durable and flexible nylon material. You can make your own snoot out of Cinefoil, craft foam, or any other malleable material that will keep its form. Simply wrap the material around the flash and secure with a rubber band. Because the material is flexible, there tends to be a natural unevenness to the edge of the light. While this is usually not an issue, if you are looking for a more precise edge, you will want to use a grid set.

Grids. Like snoots, grids reduce the spread of light—but in a much more controlled and precise manner. Grids have very distinct and uniform lighting patterns. The smaller the grid openings,

A Rogue grid and its effect.

A Strobies grid and its effect.

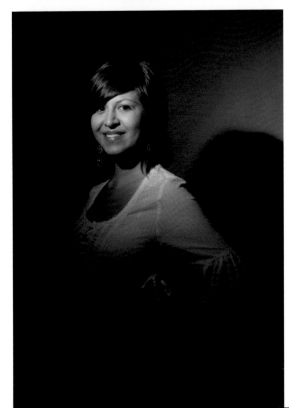

the tighter the spread of light will be. They are extremely useful as hair lights because they allow you to carefully place the light on the subject's hair without having the light spill into other areas of the frame.

Gobos/Flags. Gobo is short for "go between" and refers to anything that goes between the subject and the light. Gobos are great for casting shadows and creating patterns.

A Honl flag and its effect.

A Rogue Flash Bender and its effect.

Flags are specifically used to control the spread of your light. For example, there may be times you want to block the flash from falling on your background when you are trying to light your subject. Flags are also useful when working with bounce flash. By flagging your flash, you prevent any frontal lighting on the subject from the flash head. This means that you'll have more directional light when you bounce using a flag.

THE BLACK FOAMIE THING

The Black Foamie Thing (BFT), as it was named and made popular by wedding and portrait photographer Neil van Niekerk, is simply a piece of craft foam and a sturdy black rubber band. The BFT is attached to the flash in such a way that it becomes a flag (and at times a half snoot). The beauty of the BFT is that it is inexpensive and easy to make.

This is an invaluable tool when working with on-camera bounce flash. If you want to create short or side lighting on a subject, a flag is necessary to prevent any light from the flash head falling on the subject from the camera's perspective. It is also useful on a crowded dance floor when you are trying to bounce light from behind you. It helps prevent you from directly firing your Speedlight in the face of someone standing behind you.

A Black Foamie Thing and its effect.

HORIZONTAL MOVEMENT OF FLASH 0 DEGREES

HORIZONTAL MOVEMENT OF FLASH 45 DEGREES

HORIZONTAL MOVEMENT OF FLASH 90 DEGREES

THE DIRECTION OF THE LIGHT

We discussed earlier the role the direction of the light plays in defining the shape, dimension, texture, and color of the subject. The direction that your light comes from can also dramatically change the mood of your photograph. After all, it is the interplay of light and shadow that helps make your photograph interesting and visually appealing.

In the following section we will be discussing the angles at which you can position your flash. We will also discuss the lighting patterns that these positions create and how and when they should be used.

While there are no rules about where you have to place your flash, it's generally agreed that direct on-camera flash is the least appealing angle, since it makes the subject appear flat and dimensionless. With on-camera flash, there are no shadows to properly define the shape and dimension of the subject. (Of course, not all

HORIZONTAL
MOVEMENT OF FLASH
135 DEGREES

HORIZONTAL
MOVEMENT OF FLASH
180 DEGREES

on-axis lighting is bad; for example, it can be very useful to provide a bit of fill-flash, which we will discuss later.)

One of the great features of the Nikon CLS is the ability to take the flash off the camera. This allows you to place your flash at any point in a 360 degree circle around your subject. Take a look at the photos above and the effect of moving the flash from 0 degrees (on-axis with the subject), to 45, 90, 135, and 180 degrees around the subject.

But we shouldn't limit ourselves by only moving the flash horizontally around the subject. We also need to take into consideration that we can move the flash vertically in relation to the subject. In the sequence of images on the next page, notice how the light and shadow changes when you move the flash from 0 degrees (level with the subject) to 45 above and below the subject.

On-Axis *vs.* **Off-Axis Lighting.** On-axis and off-axis lighting refer to where the flash is pointing in relationship to the camera position.

VERTICAL MOVEMENT OF FLASH 45 DEGREES ABOVE

VERTICAL MOVEMENT OF FLASH 0 DEGREES

VERTICAL MOVEMENT OF FLASH 45 DEGREES BELOW

On-axis lighting occurs when the light points at the subject from the same position as the lens. Of course, this doesn't have to be on-camera flash—on axis flash can come from way above or below the camera position, as well. It should be also noted on-camera flash doesn't necessarily produce on-axis lighting. For example, when we bounce the flash we are directing it so that it strikes the subject from a different perspective than the camera.

Off-axis light comes from any other angle but the camera's perspective. Because the light comes from the side of the subject, it will cast a shadow across the subject. It is these shadows that help create dimension and shape in the photograph.

Be Aware of Where Your Shadows Fall. The sun is our main source of light. Because of it, we are conditioned to thinking of light as coming from above us with the shadows falling below. That's what is considered normal. Having two sets of shadows or shadows cast from below will appear unnatural. It doesn't mean that they can't work, but that they will cause a specific mood and

SB-900 in a softbox with a second SB-900 snooted as a rim light from behind. (f/4, $^1/_{160}$ second, ISO 400)

should be done with a purpose. You can determine where the light is coming from by looking at where the shadows are falling. The shadows will fall in the opposite direction of the light. This is an important consideration when using your Speedlights.

PORTRAIT LIGHTING PATTERNS

The following are some of the most common portrait lighting patterns. Lighting patterns are based on the shadows that the main light casts on the portrait subject.

BUTTERFLY
(PARAMOUNT) LIGHTING

LOOP LIGHTING

REMBRANDT LIGHTIN(

Butterfly (Paramount) Lighting. This type of lighting became popular with Hollywood photographers in the 1930s. It is characterized by a butterfly-shaped shadow below the subject's nose. To create this pattern, the main light is on-axis with the subject and placed fairly high (20 to 70 degrees). It should not be placed so high that it causes the nose shadow to touch the lip or so that the eye sockets are excessively shadowed.

Loop Lighting. Loop lighting is probably the most common portrait lighting pattern. It is named after the loop-like shadow it creates below the nose. It is popular because it lights most of the face and yet still imparts a sense of depth and dimension. To create loop lighting, the main light is placed about 30 to 50 degrees above the subject's face and 30 to 50 degrees to the right or left.

Rembrandt Lighting. Named after the famous Dutch painter, Rembrandt lighting has a very distinctive look. It is similar to loop lighting, but the main light is moved higher above the subject (50 to 70 degrees) and farther to the left or right (50 to 70 degrees). This causes the nose shadow to extend to the edge of the mouth and form a small triangle of light on the cheek (just below the eye) on the shadow side of the face. It is a more dramatic look and not necessarily an all-purpose portrait lighting pattern.

Split Lighting. Split lighting is achieved by putting the light source directly to the right or left side of the subject (90 degrees) and slightly above (20 to 30 degrees). This will leave one side of the subject's face lit and the other completely in shadow. This type of lighting has its advantages and disadvantages. It can help slim a face and

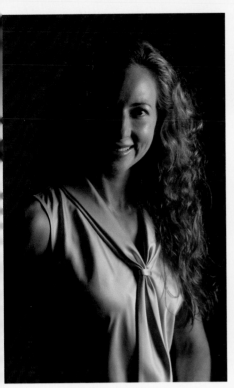

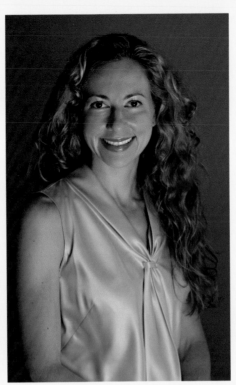

SPLIT LIGHTING

GHOUL/HORROR
LIGHTING

hide facial imperfections in shadow. However, it also accentuates texture and imperfections in the skin. This pattern is most often used on men.

Ghoul/Horror Lighting. This type of lighting is achieved by placing the light in front and below the subject's face. Because the light comes from below and casts shadows in a direction that we are not normally used to seeing, it gives a very eerie feel to the photographs. Ghoul lighting is not considered a flattering lighting pattern and should be used with caution. That's not to say that this type of lighting can't be used to make dramatic photographs, it just needs to be done with a specific purpose and with close attention to where the shadows are going.

PORTRAIT LIGHTING POSITIONS

Lighting positions have to do with the light's position and the subject's position in relationship to the camera. For example, a loop lighting pattern can be done from either a short- or broad-lighting position.

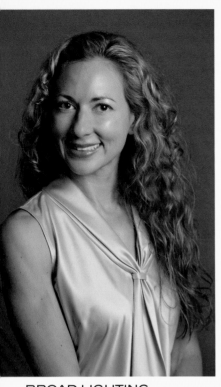 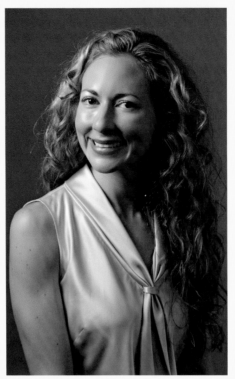

| BROAD LIGHTING | SHORT LIGHTING | FRONT LIGHTING |

Broad Lighting. Broad lighting is created by placing the light on the side of the face toward (more visible to) the camera. This tends to broaden the facial features, so it is good to use with narrow or angular faces. It is also useful for eliminating eyeglass glare, because the direct reflections from the light source are directed away from the camera.

Short Lighting. Short lighting places the light on the side of the face away from (less visible to) the camera. Short lighting works with a variety of facial shapes and is useful to make faces appear slimmer.

Front Lighting. Front lighting occurs when the light, camera, and subject are lined up on the same lateral axis. Because frontal light does not rake across the face the same way side lighting does, it's not very good for showing depth or contouring in the face. But that also makes it good for hiding wrinkles, blemishes, and imperfections in the skin. A lot of beauty and glamour lighting is frontal lighting.

5. SPEEDLIGHT TECHNIQUES

As you've probably figured out by now, it takes more than slapping your flash on your camera and turning it on to take a great photograph. Besides getting a proper exposure, you also need to think about using the proper technique to get the results you really want. In this chapter, we'll discuss some of the different techniques and the thought process behind why one technique was used over another.

DIRECT FLASH

Direct on-camera flash is probably the most common technique for those who are new to using a Speedlight. All it requires is attaching your flash

LEFT—Diana was preparing for a body-building competition when I took this photograph. I knew I wanted to take the flash off-camera so the light would emphasize her muscle definition. I chose to use direct flash because this type of photograph could handle a more defined shadow. (f/4, $^1/_{250}$ second, ISO 400, TTL flash) **RIGHT**—The well-defined shadows caused by the direct off-camera flash gave a rock 'n' roll feel to this shot of Danielle. There are two Speedlights in this shot, one to camera right and one pointing toward the model's back. (f/3.2, $^1/_{50}$ second, ISO 1000)

to your camera and pointing the flash directly at the subject. The problem with direct on-camera flash is that it isn't the most attractive lighting. Because your flash is a relatively small light source, it produces harsh, well-defined shadows. The light also comes from the same axis as the camera, making the light flat and undefined. Vertical photos taken with direct flash will have a distracting sideways shadow. And if you are working with a telephoto lens you have a greater chance of getting red-eye in your photos.

On the other hand, direct off-camera flash can create very interesting and dramatic photographs. The flash is still a relatively small point of light, so you will still have well-defined shadows—but being able to move the flash around will allow you to determine where the shadows fall. This will define the shape, depth, and dimensions of your subject.

BOUNCED FLASH

One of the most valuable features of the SB-900s and the SB-700s is that they have rotating flash heads. This allows us to bounce our light off walls, ceilings, or practically any surface that is not too far away, while the flash remains on the camera. Learning how to properly bounce your flash is an important skill for anyone who works with on-camera flash because it allows us to light our subjects with soft, directional lighting.

Sometimes direct off-camera flash is not the best choice; I decided it would be too harsh for these family photos. A quick and easy change to on-camera bounced flash produced much softer and more pleasing light. (f/ 4.5, $\frac{1}{60}$ second, ISO 800, +1EV exposure compensation for bounced flash)

| BOUNCE RIGHT | BOUNCE BEHIND | BOUNCE LEFT |

Choosing where you bounce your flash makes a huge difference in the outcome of your image. Here, you can see the difference between bouncing flash to camera right, bouncing it behind the camera, and bouncing it to camera left. There are two things to notice in these photographs. First, I was able to create broad, front, and short lighting (respectively) just by choosing where I bounced the flash. Second, notice that when bouncing to the side there is less light on the background than when bouncing the flash behind the camera. (f/4, $^1/_{100}$ second, ISO 1600)

Good bounce lighting requires more than just directing the flash in some direction away from the subject. Many photography books suggest that you tilt your flash up 45 or 90 degrees and bounce the flash off the ceiling. While this will soften the light and make it much more flattering than direct flash, it falls short of the lighting power of bounce flash. To truly master bounce flash it's a good idea to understand the angle of incidence and reflection, as well as basic lighting patterns and positions (see chapter 4).

The angle of incidence (the angle at which the light strikes a surface) equals the angle of reflection (the angle that the light is bounced off a surface). Knowing this, we can carefully choose where we bounce our flash to create all kinds of lighting patterns and effects.

It's best to think about the surface you are going to bounce your light off as the light source (rather than the flash itself). You can almost think of walls and ceilings as giant softboxes. By bouncing the light off a wall you make the relative light source (the wall) much larger than just the flash head, therefore creating much softer light. With that in mind, it's useful to think, "If I had a softbox here with me, where would I place it?" Once you have that in mind, bounce your flash toward where you would have placed a softbox.

There are a couple of other things to keep in mind when working with bounced flash. First,

you will generally lose a couple stops of light depending on the subject distance, the bounce distance, and the color and reflectivity of the surface you are bouncing off. While the TTL and auto

FACING PAGE—For this cake image, created for a magazine feature, I didn't have enough room to place a stand with a softbox in the correct position. Once again, I was able to properly light my subject by bouncing my flash off the wall to camera left. (f/4, $^1/_{100}$ second, ISO 800)

BELOW—After photographing a large group of people, I was asked to take a headshot of one of the executives. I had only a few minutes to take this shot and didn't have time to fetch a softbox. Bounce flash to the rescue! By choosing to bounce my flash to camera left, I was able to produce softbox-quality lighting. The flash was flagged with a Black Foamie Thing (see chapter 4). (f/4, $^1/_{125}$ second, ISO 800)

modes will compensate for this loss of light, you may still find yourself adjusting the flash exposure compensation up to get a proper exposure.

Second, you will want to take note of any colored surfaces you might be bouncing flash off. The color of the bounce surface will be transmitted back to the subject. If you bounce off a red wall, you will have a red cast to the lighting on your subject. While this might be a cool effect, it is generally best to bounce off a white or neutral surface—or adjust your camera's white balance.

The spread of light from bounce flash can be further controlled and shaped by using a flag or snoot.

HIGH-SPEED SYNC

As mentioned earlier, high-speed sync (HSS) is a very helpful mode that allows you to use your flash at shutter speeds above the maximum flash sync speed. Instead of sending out one single burst of light, in this mode the flash sends out multiple bursts to follow the shutter as it moves across the image plane. This ensures that the frame is completely illuminated by flash. HSS is particularly useful when you want to work at wider apertures in daylight without overexposing your background, or when you want to use movement-stopping shutter speeds above the maximum flash sync speed.

So how do you get the most out of working with HSS in i-TTL mode? The first things you want to consider are the background and the ambient light exposure. Some photographers teach that you should underexpose your background for dramatic photos. This type of thinking is not completely correct. The truth of the matter is that you should expose the background for the

effect that you want. If you want a more dramatic sky, choose the correct exposure for the sky. If you have time, it is always a good idea to compose your photograph and take a test shot to ensure you are properly exposing for the ambient light before adding flash.

It is important to note that HSS greatly reduces the power output of your flash. It takes a lot of energy to produce continuous light, so expect a reduction in maximum power of between 2 and 3 stops. One of the benefits of i-TTL is that it will compensate for the demand in power—though you will still probably need to increase your flash exposure compensation by 1 to 3 stops. (*Note:* I have heard some photographers recommend reducing your camera's exposure compensation by 1 to 2 stops and increasing your flash exposure compensation by 3 stops. That is the Canon method of doing things; on Nikon cameras, adjusting the overall exposure compensation on the camera adjusts the exposure for both the flash *and* the ambient light.)

To create the photograph below, I first chose the exposure I wanted for my sunset (right). I knew that I wanted a shallow depth of field because I wanted the background to go a bit soft. The final exposure for the background was $^1/_{1600}$ second at f/4. I increased the FEC on my flash to +3EV and moved the flash to just outside the camera frame for the final capture of the couple.

WITHOUT FLASH **WITH FLASH** **FINAL PHOTO**

By adding just a bit of fill flash to this scene I was able to create more attractive light on Lindsay and warm up the photograph's color balance. (f/4.5, $^1/_{320}$ second, ISO 250)

FILL FLASH

When photographing a portrait outdoors in deep shade, you will probably want to provide a little fill flash to a scene to open up deep shadows and provide catchlights in the eyes. When working in deep shade with the automatic white-balance mode, providing a bit of fill flash can also warm up the scene.

Nikon Speedlights automatically set to TTL-BL as long as the camera metering is not set to spot metering. While this mode does a good job of balancing the flash with the ambient light, you might still want to reduce the exposure compensation value by 1 to 2 stops. The goal is only to get just a kiss of light, not to make it look like a flash was used. In regular i-TTL mode, you can also reduce the FEC by 1 to 3 stops to provide just a small amount of fill flash.

BALANCING AMBIENT LIGHT

The best flash photographs usually do not make it apparent that flash was used. The flash should be used to highlight the subject and add drama, depth, and dimension, but it should not be the main thing you notice when you look at a photograph. To fully achieve this, it is important that your flash has the same characteristics as the ambient light. These characteristics include the direction and the color of the ambient light. The flash intensity should also not be dramatically different than the exposure for the ambient light.

When shooting in sunlight, one of the first telltale signs that a photograph was lit by flash is that the shadows in the image are falling in multiple directions. There is only one sun in our sky, so the shadows should only fall in one direction. While some types of photography will cross-light

ABOVE—I loved how the sun was reflecting off the buildings in the background, but when I properly exposed for my couple, the background became overexposed (left). By adding a bit of flash in a softbox, I was able to properly balance the light between my subjects and the background—and have it look natural (right). (f/4, $\frac{1}{250}$ second, ISO 400)

BELOW—A bit of bounce flash to camera left provided clean lighting on the bride (left). It looks natural and is much more attractive than the available light alone (right). (f/2.8, $\frac{1}{100}$ second, ISO 1600)

To deal with the intense sun that was making the couple squint, I moved them into the shade, gelled a Speedlight with a $\frac{1}{2}$ CTO gel, and made sure that the light was coming from the same direction as the sun. The Speedlight was able to replicate the sunlight—and eliminate the problem of squinting. (f/5, $\frac{1}{200}$ second, ISO 125)

the subject for an effect, if you want your flash to look natural, you must keep the direction of the shadows in mind. The length of the shadows should also match those of the ambient light. Long shadows indicate that it's early or late in the day; short shadows indicate that it's midday.

The other thing that can draw attention to the fact that you used flash is if the color of the flash and the ambient light do not match. Speedlights naturally have a color temperature of about 5500K, which is about the same as midday sun. When shooting closer to sunset or indoors in tungsten lighting, the ambient lighting will be much warmer (2500–3800K) than the light your Speedlight produces. As a result, the light from

the Speedlight will appear blue in comparison. The best way to deal with this is to gel your flash.

GELLING YOUR SPEEDLIGHT

Gels or colored filters are thin colored sheets of acetate that are placed over the flash head to change the color of the light coming from it. They come in all different colors and in varying degrees of color intensity.

The SB-900 and SB-700 both come with corrective amber (for tungsten lighting) and green (for fluorescent lighting) filters. Additional filters in different colors can be purchased for the flashes. The SB-900 has a sensor on the flash head

On the left is the image shot without a gel. For the image on the right, I added a $^1/_2$ CTO gel to balance the color temperature of the flash to the ambient light. (f/2.8, $^1/_{60}$ second, ISO 1250)

that is able to read the code printed on the tabs on the filter. The information about the filter is transmitted to the camera so a more accurate white balance can be achieved. The camera must be in the automatic or flash white-balance mode for this feature to work properly. The SB-700 has a flash menu feature that lets you choose the color of the filter you are using. Again, this helps the camera achieve a more accurate white balance.

Changing out the filter in the supplied filter holder for the SB-900 can be a bit time-consuming when you are in a hurry. Several companies, such as Honl, have a Velcro strap that attaches around the flash head and lets you attach oversized gels to the strap, which makes it quick and easy to change the gels. The gels come in a wide selection of corrective and creative colors.

Many photographers also buy large sheets of filter material to cut their own gels to fit their Speedlights. The gels are attached with gaffer's tape to the flash. This is the most economical way to quickly and easily gel your flash.

There are two main reasons to gel your Speedlight: to correct the white balance/color temperature or to add creative effects.

Corrective Gels. Mixing light sources with different color temperatures can lead to ugly colors in your photographs. The most common example situation occurs when you combine warm (2800K) tungsten ceiling lights with flash. The ceiling lights will create harsh shadows in the eye sockets, but when you add in light from a cool (5800K) flash, the shadowed areas that are illuminated with flash take on a blue cast. It is

A variety of colored gels.

almost impossible to correct for the different color temperatures in postproduction. Therefore, the best way to handle a mixed-lighting situation is to gel your flash for the ambient light. Simply choose the colored gel that matches the color temperature of your ambient light and apply it to your flash.

Creative Gels. Gels come in a rainbow assortment of colors, so you can change a drab, boring, or neutral-colored room into something extraordinary by simply gelling your background light.

While most people use tungsten correction gels to match their Speedlight's color temperature to the color temperature of the existing light, you can also use them creatively. There are three things to consider when doing this: the gelled Speedlight's color temperature, the existing light's color temperature, and your camera's white balance. By changing any one of these you can create photographs that have a very different feel to them.

Changing the color of the background is easy when you gel your background light. I liked the look of the ring light, but I felt the background was dull (left). Adding a red gel to the background light was easy to do and really made the image pop (right). (f/4, $^1/_{125}$ second, ISO 400)

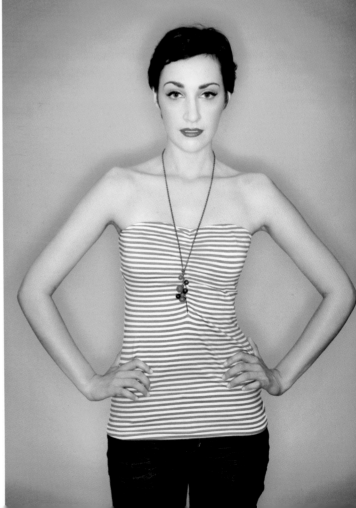

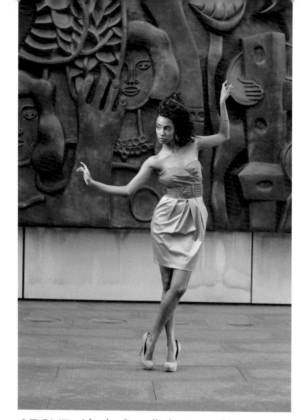
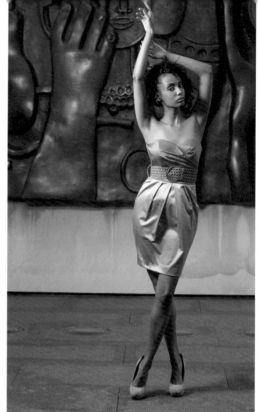

ABOVE—I had a Speedlight in a softbox illuminating the model, Feleg. A second flash with a purple gel was pointed at the wall behind her to illuminate the wall and give it that purple color. Here, you see the results with and without the purple gel. (f/4, ¹/₂₅₀ second, ISO 200)

BELOW—I fitted the main light with a full CTO gel and set the camera's white balance to tungsten to match it. The background light was an unmodified Speedlight. Because the color temperature of the Speedlight is much higher than tungsten lighting, the light from the background Speedlight appears blue. (f/4, ¹/₆₀ second, ISO 800)

6. OFF-CAMERA FLASH

As we've shown in the various examples so far, direct on-camera flash generally lacks the depth, dimension, and drama that directional light gives. One way to create beautiful directional light is by changing the angle of the Speedlight's flash head and bouncing the light. Another way to achieve directional light is to take your Speedlight off the camera.

The SC-29 cord.

I-TTL COMMUNICATION

When the flash is off-camera, the flash and camera obviously still need to communicate about when to fire the Speedlight. There are three ways to maintain i-TTL communication: flash cords, Nikon's advanced wireless lighting (AWL) system, and TTL radio triggers.

FLASH CORDS

Nikon produces two TTL remote cords, the SC-28 and the SC-29. These cords simply attach to the hot shoe of the camera and

Holding my Speedlight in one hand and having it connected to my camera in my other hand by the SC-29 cord allows me to quickly move my flash to any position I want. I love how moving the flash below caused the large shadows to be cast on the walls behind the dancing guests. (f/3.2, $^1/_{60}$ second, ISO 1250)

the flash slips into the hot shoe at the other end of the cord. It's a simple and secure connection. The difference between the two cords is that the SC-29 also has an AF-assist illuminator built into the end that locks into the camera's hot shoe.

ADVANCED WIRELESS LIGHTING

Nikon's advanced wireless lighting (AWL) system give you the flexibility of using multiple off-camera flashes in TTL mode—without wires. This is probably one of the greatest strengths of the

CHANNELS

The Nikon CLS provides four different channels to fire your remote flashes. This allows up to four photographers to work in close proximity without triggering each other's flashes. Your master and remote flashes need to be on the same channel for them to work together. (If you are having trouble triggering your remote flash and it is within line of sight, check the master flash's channel to make sure it matches the remote.)

GROUPS

Groups allow you to independantly control the flash mode and flash output compensation values for each flash, master and remotes, in your remote setup. This allows you to fine-tune your flash exposure easily and quickly from your master flash. You can assign one flash or multiple flashes to each group. The SB-900 has four groups: the master and three individual remote groups (A, B, and C). The SB-700 controls two individual remote groups (A and B). As a remote, the SB-700 can work in one of three remote groups.

FRESH BATTERIES ARE CRITICAL

It is extremely important that you are using fresh, fully charged batteries when working with wireless flash. The instructions for how much power to emit are transmitted in the pre-flashes. If there is not enough power to send or receive the complete set of instructions in the pre-flash, you can experience some fairly erratic behavior from the remote flash. Not knowing exactly how much flash power to output, it may make a full power exposure followed by an exposure that is several stops under. If you experience this, the first thing to do is change out your batteries. That will generally resolve any issues with erratic exposure.

CLS. You can have up to three different groups of flashes with multiple flashes firing within each group. The power level of each group can be controlled independently, letting you have more creative control over your lighting.

With AWL, the master flash or commander communicates with the remote flashes through a series of pre-flashes in the i-TTL mode. These pre-flashes are used to determine a correct exposure. But with AWL, they also relay information to the remotes about the channel, group, and how much light the flash is supposed to emit.

The basic concepts involved in setting up and using the AWL are quite simple. You will start with a master Speedlight on your camera. (You can also use a built-in commander, like the D700's pop-up flash, or a commander-only unit, like the SU-800, as the master unit.) You can choose to have this flash and add to the expo-

In the above photo I bounced on-camera flash to illuminate Amanda and Clark, but I felt it illuminated too much of the room, detracting from the couple and the sunset behind them. In the photo to the right, I took the Speedlight off-camera and used the built-in commander of the D700's pop-up flash to trigger the Speedlight. I had my assistant point the Speedlight directly at the couple and slightly snoot it with his hands. (f/4.5, $^1/_{125}$ second, ISO 320)

sure, or you can set it up as a commander only—so that all it does is communicate with the remotes, telling them how much flash output to give. The remote flashes will then be placed within line of sight of the master unit. You must make sure that the light sensor window for each wireless remote flash is turned toward the master flash so that it can see the master flash's instructions. The range of effectiveness is limited to 30 feet in front of the master unit and 23 feet to each side.

Setting up AWL for the SB-900. The SB-900 allows you to control three groups (A, B, and C) of flashes. Each group can be set with a different mode and/or flash output level.

Begin by setting an SB-900 as the master flash. To do this, turn the power switch while holding down the button in the center to

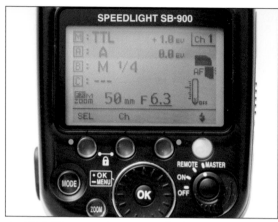

An SB-900 set as the master flash.

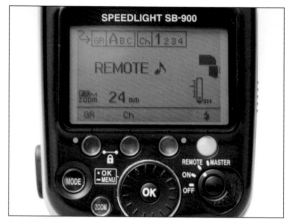

An SB-900 set as a remote flash.

master. (It's that easy.) To set the flash mode, press function button 1 on the master flash unit to highlight M (M = master flash unit). Press the mode button, then turn the selector dial to choose the desired flash mode. Press the OK button to confirm the setting. You have a choice of TTL, A (auto), M (manual), and "- - -" (no light output commander mode; though a pre-flash will occur in this mode).

To adjust the flash output level, press function button 2. Turn the selector dial to choose the desired flash output. Press the OK button to confirm the setting. To reach the next group, press function button 1 again. You can use the selector dial to choose which group you need to adjust. To set the mode and power output of the other groups, repeat the above steps. After setting the mode and power output, press the OK button twice to reveal "Ch" (channel) above function button 2. Press function button 2, then turn the selector dial to choose the channel number. Press the OK button to confirm the setting.

To set an SB-900 as a wireless remote unit, turn the power switch while holding down the button in the center to remote. To set the group,

press function button 1 and turn the selector dial to choose the desired group. Press the OK button to confirm the setting. To set the channel, press function button 1 and turn the selector dial to choose the desired channel. Press the OK button to confirm the setting. All flash modes and flash output levels are controlled from the master flash.

Setting up AWL for the SB-700. As a master, the SB-700 allows you to control two groups of flashes (A and B). However, unlike the SB-900, it does not let you work in different modes between the different groups. They must all be in TTL or all in manual mode. As a remote, the SB-700 can be set to group A, B, or C if using the SB-900 or the SU-800 as the master.

To set the SB-700 as the master flash, turn the power switch while holding down the button in the center to master. Set the mode selector to TTL or manual. All groups will operate in the same mode. To adjust the flash compensation value/output level, press the SEL button. Turn the selector dial to choose the desired flash output. Press the OK button to confirm the setting. To reach the next group, press the SEL button

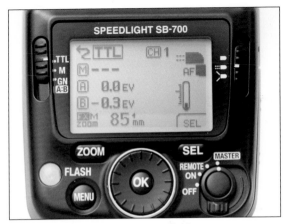

An SB-700 set as the master flash.

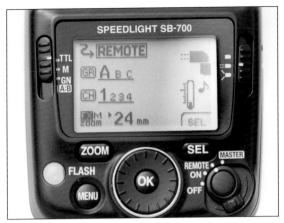

An SB-700 set as a remote flash.

again and repeat this step with groups A and B to set the output level. To select the channel, press the SEL one more time. Choose the channel with the selector dial and then press OK to confirm the setting. (*Note:* To cancel the flash function for the master flash or any groups, highlight the compensation value and rotate the selector dial until you see "- - -". While the master flash will not fire, it will still use a low power pre-flash to communicate with the remote units.)

To set the SB-700 as a wireless remote unit, turn the power switch while holding down the button in the center to remote. To set the group, press the SEL button to highlight the group and turn the selector dial to choose the desired group. Press the OK button to confirm the setting. To set the channel, press the SEL button again to highlight the channel. Turn the selector dial to choose the desired channel. Press the OK button to confirm the setting.

The SB-700 also offers a quick wireless control mode that allows you to balance the output level ratio of two remote flash unit groups. This is a great option for portraits when you want a specific ratio between the main and fill lights. To set it up, turn the power switch to master and move the mode selector switch to A:B. Press the SEL button to select the flash output level ratio of groups A and B of the remote flash units. Rotate the selector dial to select the correct ratio. Press OK to confirm the setting. Set up the remote flashes to the appropriate groups and channels as outlined above.

I-TTL RADIO TRIGGERS

AWL is very powerful, but it does have its limitations. First, it requires that the Speedlights have a line-of-sight connection and that the remotes be no farther than 30 feet from the commander/master flash. Because the units communicate via relatively weak pre-flashes, bright midday sunlight can also interfere with the communication between the units.

Anyone who needs wireless technology but might not be able to consistently maintain a line-of-sight connection (like event and wedding photographers) should strongly consider investing in i-TTL radio triggers like those offered by PocketWizard and RadioPopper. Like the AWL system, these i-TTL radio triggers allow full con-

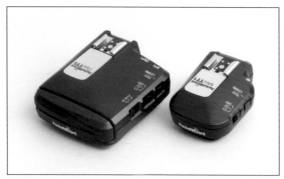

The PocketWizard Mini TT1 and FlexTT5.

trol of multiple off-camera Speedlights in i-TTL mode. They also allow you to work in high-speed sync. (Most standard manual radio triggers only allow you to work in manual flash mode at the maximum flash sync speed or slower.) Additionally, they have a much greater range (800 feet for the PocketWizards; 1500 feet for the RadioPoppers) and don't require a line-of-site connection.

While both the PocketWizard and RadioPopper systems offer i-TTL control of off-camera flashes, each goes about it differently. It should be noted that this technology is still relatively new and is constantly being improved upon.

PocketWizard. The PocketWizard line of i-TTL radio components consists of several devices designed specifically to function with your Nikon gear. The Mini TT1 transmitter locks onto the camera's hot shoe, supporting an on-camera flash with its own hot shoe while controlling one or more remote PocketWizard receivers or transceivers (like the FlexTT5). The FlexTT5 transceiver can be used on-camera, where it works

Weddings are fast-moving events. When taking this photo I was surrounded by a lot of guests trying to take their own photographs. Shooting with the PocketWizard units meant I didn't have to worry about maintaining a line-of-sight connection with my remote Speedlight. For this shot I had one Speedlight on-camera with a diffusion dome. The FEC on this unit was set to –2EV. A second Speedlight with a PocketWizard unit was on a monopod, held by an assistant, to camera right. Its FEC was 0EV. (f/2.8, $^1/_{60}$ second, ISO 1000)

One of the things I love about i-TTL radio transmitters is the ability to control my flash output from a master Speedlight on the camera. Above you can see the lighting setup with a Mini TT1 and AC3 ZoneController on-camera, one SB-900 in a softbox with a FlexTT5, and another SB-900 as rim light with a FlexTT5 (FEC at −2EV). The exposure of this image was f/2.8 and ¹/₆₀ second and ISO 800.

identically to the Mini TT1 transmitter. Off-camera, it can be used under a remote flash for seamless power control. (*Note:* If you prefer, you do not need to have a Speedlight attached to the camera's Mini TT1 or FlexTT5. This keeps the camera profile smaller and lighter. It's an important advantage of the PocketWizard system.)

The hot-shoe mounts and the switches on the side of the PocketWizard trigger make the system very easy to set up and use. If you use a Speedlight as a master flash on-camera, set the Speedlight to master and set your modes, groups, and channels accordingly. For the remote Speedlight, turn the flash to "on" (not remote) and make sure the mode is set to TTL. Then, make sure the correct channel and group are selected on both the transmitter and receiver. (*Note:* It is important to turn on the PocketWizard Radios from

MOUNTING YOUR OFF-CAMERA FLASH

When you take your Speedlight off the camera you'll more than likely attach it to a light stand or monopod via a cold shoe. The only problem with cold-shoe mounts is that they tend to be unreliable. Most flashes use a pin-and-lock system to attach to the camera, but cold shoes are generally built without these. The only way to secure the Speedlight is to have the cold shoe tightened around the flash foot, which isn't terribly secure.

Then came the Frio. The Frio has two very powerful things going for it. First, it features a dual-locking system. Second, it is much easier to use than a regular cold shoe. The dual-locking

The Frio securely connects the Speedlight to a softbox.

The Frio.

comes from a pressure release tab on the Frio and the pin-and-lock system on the flash. It's easier to use than a normal cold shoe because it doesn't require you to tighten any knobs. Simply push the flash into the Frio and it is securely locked into place. The Frio fits any flash, including the Nikon SB-900, and mounts to anything with a male $\frac{1}{4}$ inch 20tpi standard tripod stud. (The $\frac{1}{4}$ inch 20tpi socket is metal, so it's sturdy and won't get stripped with regular use.)

I have replaced all the cold shoe connectors on my Interfit and Lastolite softboxes with Frios. I usually have my softboxes mounted on a monopod and held by an assistant. When we are on location, we are on the move—and now I no longer have that nagging fear that the cold shoe will fail.

the top down, which means the flash, the PocketWizard trigger, and then the camera get turned on in that order.) In practice, the PocketWizard system works by interpreting the CLS/i-TTL data being sent through the camera's hot shoe, converting it into its own proprietary code, and digitally transmitting it as a radio signal to the receivers. This is what allows the PocketWizard System to add functions beyond those offered by the Nikon CLS.

If you need to adjust groups of Speedlights, you can attach a master flash (set to master), an SU-800, or the PocketWizard AC3 ZoneController to the hot shoe of the MiniTT1 or FlexTT5. All three of these options will allow you to control the flash output of the remotes in groups and change the flash modes for the remotes

between i-TTL and manual. (*Note:* You can adjust flash exposure compensation on some Nikon camera bodies. The D3 series bodies don't have FEC on the body, but in a pinch you can use the overall exposure compensation to affect the flash when you are shooting in manual exposure.)

RadioPopper. The RadioPopper system works a little differently than the PocketWizard system. Instead of intercepting and sending its own proprietary code, the RadioPopper transmitter senses the Speedlight's pre-flash commands and sends them via radio waves to the receiver. The receiver then decodes the radio message into a series of infrared pulses that the remote Speedlight is able to see as if they had been sent directly from the master flash.

The RadioPopper PX system is comprised of a transmitter and a receiver. The transmitter sits on top of the master flash head. You can either use Velcro or attach it with an elastic band to the Speedlight. The receiver has a special mount that places the unit directly in front of the remote Speedlight's light sensor. It is important to make sure that the receiver is mounted correctly in front of the sensor so that it can properly read the infrared pulses that the receiver translates.

The RadioPopper PX.

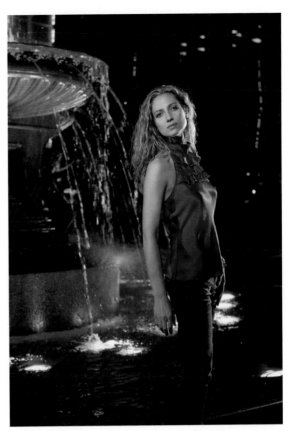

Being able to move around my subject to get different angles—without worrying about a line-of-sight connection with my remote flashes—allows me to work more quickly and focus more on my subject. (f/4.0, $^1/_{60}$ second, ISO 800)

One on-camera Speedlight was set to commander mode with a RadioPopper transmitter. I added one SB-900 on a monopod to camera left, acting as the main light with a RadioPopper receiver and one SB-900 with a RadioPopper receiver behind Tammy as a rim light.

Let them eat cake! For this magazine feature about wedding cakes, I had to properly light both the model and the cakes. I took the black cover off a convertible umbrella to create a shoot-through umbrella and placed it to camera right. To make sure that both the cakes and the model were separated from the dark background, I added a second unmodified Speedlight as a rim light to camera left and dialed down the exposure 2 stops. (f/5.6, $^1/_{60}$ second, ISO 800)

The RadioPopper system requires that you use either a flash set to master or the SU-800 commander. (For those cameras with a built-in flash, the RadioPopper system has an attachment that allows you to use the RadioPopper with the built-in flash as a commander.) The nice thing about the RadioPopper units is that even with the units on the master Speedlight you can continue to trigger remote Speedlights with CLS, even if the remote does not have a RadioPopper trigger attached to it. (Normal CLS limitation such as line-of-sight connection would still apply in this instance.)

To set up the RadioPopper triggers, set up your Speedlights as you normally would when using CLS. Make sure you are on the correct group and channel. All your RadioPopper units need to be working on the same channel. Also, make sure that you are working in the Nikon mode; RadioPopper units are able to work with either Nikon and Canon systems by changing a menu setting.

For this image of Dr. Pearce, I loved the juxtaposition of the top hat and the goggles—and I knew I wanted to add to the mood with some dramatic lighting. Working in i-TTL, the first capture (top left) was a bit overexposed, so I dialed it down –1.3EV for the second frame (center left). But I didn't like how there was no separation between the coat and the background. By adding a second light (bottom left I was able to provide separation to create a very distinct mood in the final photograph (above). (f/4, $^{1}/_{200}$ second, ISO 400)

These photos were taken on a set of stairs in complete shade. The first photo was lit by an SB-900 in a softbox. While it is a nice photo, the real magic came when I added a second light at the top of the stairs behind her. It makes it look like she is sitting on a flight of sun-drenched steps. (f/4, $\frac{1}{250}$ second, ISO 200)

Make sure that your batteries are completely charged and the receiver is properly mounted to the remote flash.

MULTIPLE SPEEDLIGHTS

As we discussed in the section on AWL, the Nikon system allows you to control multiple flashes in as many as three groups. This lets

you better control and fine-tune your flash exposure and lighting. Multiple lights are also useful to better expose different parts of a scene, provide visual interest, better show your subject's shape and dimension, or even completely change the mood of an image.

Understanding the Role of Each Light. It is always a good idea to think of how each Speedlight affects the scene separately. You might want one Speedlight to overexpose the background. You might want another Speedlight to act as a rim-light. You could use one Speedlight to provide just a touch of fill light. By understanding exactly what you want, you can easily control and set the different Speedlights to achieve your goal.

Using Multiple Lights to Illuminate a Room. When photographing a wedding reception, there is usually a lot of action involving many people. My goal is always to focus on the bride and groom while still making sure to feature all the other guests. I like to bounce my on-camera flash to provide soft lighting on the main subject and add in a second Speedlight on a stand to provide definition to the people in the background. I use i-TTL radio triggers when working with remotes as room lights. It is too easy to lose line-of-sight connection with the remote Speedlights when working in such an active situation.

The groom was lit by flash bounced off the ceiling a bit behind and to the right of the camera. However, there was too much light fall-off between the groom and the guys waiting to catch the garter. Adding a second light separated them from the dark background and properly exposed them. (f/4, $^1/_{125}$ second, ISO 1600)

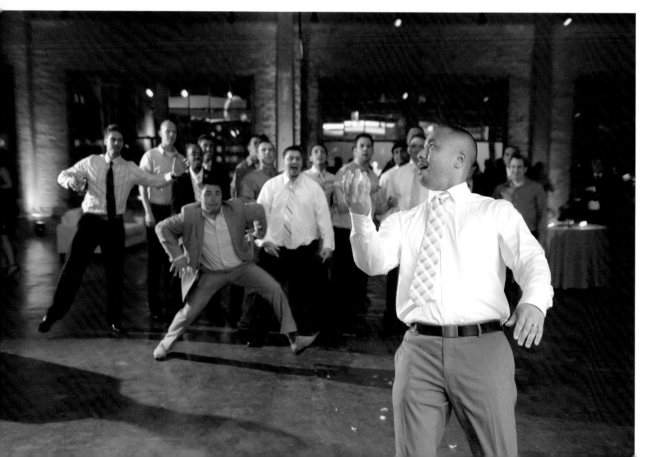

For this outdoor reception at night, there was no place to bounce my flash. To give the photo depth and definition I placed an unmodified Speedlight to camera left at the back of the seating area. (f/2.8, $^1/_{60}$ second, ISO 1600)

Here, I used a second Speedlight on a stand pointed at the back of the couple to throw their shadow onto the wall. I feel that the shadows created by using a second flash add to the visual interest of the photograph. (f/3.5, $^1/_{60}$ second, ISO 1000)

At a wedding reception, things are constantly moving. If your flash is pointed into the room, it's easy to accidentally get the flash itself in the frame—and the resulting flash flare. Some people might find this distracting. Other people may find it an acceptable style. (f/2.8, $^1/_{100}$ second, ISO 1600)

7. THE PHOTO SHOOTS

Now that we've discussed all the equipment and techniques available to us as part of the Nikon CLS, let's take a look at how we can apply them to several different photo shoots. When you work on location, you will be faced with many different options and even challenges to create a great photograph. Hopefully this will give you an idea of how to set up and adjust your lighting.

THE BLACK WIDOW

LOCATION: Colonnade outside an abandoned church (working in near darkness)
EQUIPMENT: Three SB-900 Speedlights, monopod, PocketWizard FlexTT5, Nikon D700 camera
CAMERA SETTINGS: f/2.8, 1/30 second, 1250 ISO
FLASH SETTINGS: TTL, FEC 0EV for main light, FEC –1EV for backlight

It was so dark when we started shooting that I had to use a flashlight to even see where Diana was standing so I could properly focus.

We were going for a "black widow" look, so I wanted the scene to have a mysterious feeling.

One Speedlight, with a PocketWizard FlexTT5, was attached to a monopod to be the main light. I adjusted the zoom to 135mm on the head, creating more of a spotlight effect. A second Speedlight and PocketWizard FlexTT5 were placed on a window sill in the background to provide rim light (images 1 and 2).

While I liked the effect of the first setup, I found the flare to be a little too much and adjusted the second Speedlight to function as a background light. You can see the difference between using and not using the background light and how it completely changes the feel of the photograph (images 3 and 4).

IMAGE 1

IMAGE 2

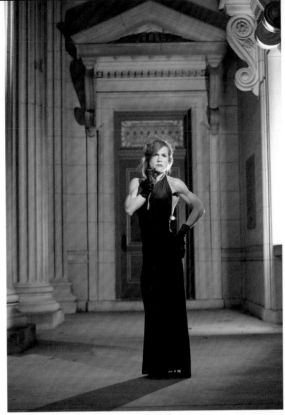

IMAGE 3

IMAGE 4

Finally, I moved Diana over to the columns for one last photo (image 5). The main light was still an unmodified Speedlight on a monopod and the second Speedlight was used as a rim light.

In all of these photographs, I used the PocketWizard FlexTT5 to trigger my flashes. This was necessary because the flash on the window sill was not within line-of-sight of my master flash. I used a master flash on top of the PocketWizard FlexTT5 to adjust the FEC of the remote flashes.

IMAGE 5

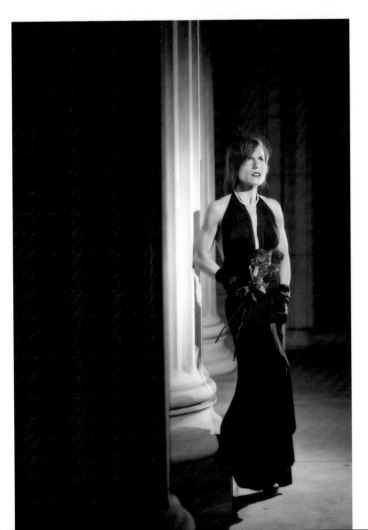

IMAGE 6

IMAGE 7

BIKING IN RED ROCKS

LOCATION: Red Rocks, Nevada (40 degree weather; colder than we would have liked)

EQUIPMENT: Four SB-900 Speedlights, three light stands, Nikon D700 camera

CAMERA SETTINGS: f/8, $^1/_{250}$ second, ISO 400

FLASH SETTINGS: TTL, FEC 0EV, triggered using the Nikon AWL system

Ray had recently gotten back into biking when I took these photos. He wanted a dramatic portrait in a picturesque landscape, so Red Rocks seemed like the perfect location.

We set up three flashes on light stands: one as the main light and two as kickers to add dimension to his body. They were all controlled by a fourth master Speedlight on the camera. This was set to commander mode so that it didn't add any light to the exposure (images 6 and 7).

To conserve battery power and get the most output from my flashes, I worked at the maximum flash sync speed ($^1/_{250}$ second). Based on my meter reading, a $^1/_{250}$ second exposure meant my f-stop would be f/8 to properly expose for the sky and landscape. Since the ISO setting also has an impact on exposure, I could have reduced or increased my ISO to reduce or increase my f-stop. However, I felt that f/8 provided a good depth of field for this photograph.

For the last photo of Ray riding through the desert (image 8), I increased my shutter speed to $^1/_{500}$ second to ensure I stopped the motion.

IMAGE 8

IMAGE 9 (ABOVE)
IMAGE 10 (RIGHT)

THE KITCHEN TABLE

LOCATION: A kitchen table
EQUIPMENT: Three SB-900 Speedlights, light
 stand, Nikon D700 camera
CAMERA SETTINGS: f/16, $^1/_{250}$ second, ISO 200
FLASH SETTINGS: i-TTL, FEC 0EV

Even in the confines of a messy kitchen it is still possible to take a dramatic portrait. By using your camera settings to kill the ambient light and Speedlights as the main source of light, you can create great portraits anywhere. The main light and background light were controlled by an on-camera master flash set to commander mode (image 9).

At f/2.2 and $^1/_{80}$ second (image 10), there was still enough ambient light to show we were sitting in a kitchen. By changing my settings to f/16 and $^1/_{250}$ second (image 11), I ensured that the ambient light would not register. I also zoomed in my flash head and used a piece of paper to snoot the Speedlight just a little bit more.

IMAGE 11

THE ART DECO COUCH

LOCATION: The lounge of an art deco hotel

EQUIPMENT: Three SB-900 Speedlights, mono-
pod, RadioPoppers, Nikon D700 camera

CAMERA SETTING: f/2.8, $^1/_{100}$ second, 1000 ISO

FLASH SETTINGS: TTL, FEC –1EV for main light,
FEC –1.3EV for accent light. Each Speedlight
was equipped with a RadioPopper. The main
light and accent light were controlled by an
on-camera master flash set to commander.

My camera's white balance was still set to tung-
sten from a previous shoot when I took the first
photograph from this session, but I found the
unnatural color palette appealing and decided to
continue using it (images 12 and 13).

I liked the spotlight effect of the direct flash
on Mallory, but I didn't like how there was no
definition to her legs. To address this, I placed a
second accent Speedlight on the floor to camera

IMAGES 12 AND 13

IMAGES 14 AND 15

right and aimed it toward her legs. While it properly illuminated her legs, it also caused a distracting cross shadow on the couch (images 14 and 15). By using a piece of black foam to flag my flash I was able to better control the light falling on her legs (images 16 and 17).

For comparison, I also photographed our beautiful model in the same setup with a softbox and a more accurate color balance. You can see how these changes created a totally different mood in the shot (images 18 and 19).

IMAGES 16 AND 17

IMAGES 18 AND 19

| IMAGE 20 | IMAGE 21 | IMAGE 22 |

ENGAGEMENT SESSION WITH STYLE

LOCATION: A cool old building in St. Louis

EQUIPMENT: Three SB-900 Speedlights, monopod, softbox, three PocketWizard FlexTT5 units, Nikon D700 camera

CAMERA SETTINGS: f/2.8, $^1/_{60}$ second, ISO 1000

FLASH SETTINGS: Main light i-TTL with FEC 0EV, background light at manual power

In this session, you'll see the value of moving around your subjects and always being willing to change up your lighting to get several different looks from one setting.

For this shoot, all the Speedlights used PocketWizard FlexTT5s. The main light and background light were controlled by an on-camera master flash set to commander mode.

In the first photograph (image 20), I had just a Speedlight in a softbox on a monopod. This failed to show off the very ornate door behind Alison and Keith. I put a Speedlight on the ground aimed up towards the door. You can see the effect of just the background light in the second photograph (image 21). In the final photo you can see how using the background light made a more interesting photograph (image 22).

In the second set of photographs (images 23 to 26), I placed the second Speedlight on the ground behind them. You can see the difference between no flash, $^1/_4$-power manual flash, and full-power manual flash. I like the way the full-power flash blows out the background.

In the final set of photos (images 27 and 28), you can see how changing your camera position can change the look of your photographs. The lights are in the same position as the previous setup. In the first photograph, the second Speedlight acts a kicker to help separate the couple from the background. In the second photo, it becomes a background light. Never forget to move around your subjects. It allows you to get a variety of images in a short period of time.

IMAGE 23 (TOP LEFT)

IMAGE 24 (TOP CENTER)

IMAGE 25 (TOP RIGHT)

IMAGE 26 (RIGHT)

IMAGE 27

IMAGE 28

RED EYE

LOCATION: St. Louis City Garden

EQUIPMENT: Four SB-900 Speedlights, monopod, softbox, four PocketWizard FlexTT5 units, Nikon D700 camera

CAMERA SETTINGS: f/5.0, $\frac{1}{250}$ second, ISO 200

FLASH SETTINGS: Main light i-TTL and FEC 0EV, two background lights in sculpture with red gels set for $\frac{1}{1}$ (full power) manual

Sometimes I like to put light where it doesn't really belong. When I first saw this hollow sculpture, I thought about how cool it would be to make the eyes glow red.

I began with a red-gelled Speedlight in the sculpture, but it wasn't powerful enough to give the proper effect. I ended up placing two Speedlights in the sculpture, each with a PocketWizard FlexTT5. The main light and background light were controlled by an on-camera master flash set to commander mode. The light on Feleg was from a Speedlight in a softbox (image 29).

For these two additional photos, I moved Feleg to the opening of the sculpture. You can see the red-gelled Speedlights going off in the sculpture (image 30) and what the scene was like without any additional lighting (image 31).

IMAGE 30 (LEFT)

IMAGE 31 (RIGHT)

THE UMBRELLA

LOCATION: A grassy field

EQUIPMENT: One SB-900 taped into the pink umbrella, two PocketWizard FlexTT5s, Nikon D700 camera

CAMERA SETTINGS: f/2.8, $^1/_{10}$ second, ISO 1600

FLASH SETTINGS: Main light i-TTL at FEC −1.7EV

While it's not an original concept, I wanted to create my own photograph in which the light in the scene came from inside an umbrella. With the help of gaffer's tape and a PocketWizard FlexTT5, I was able to place the Speedlight in the umbrella and trigger it. Because the flash was so close to my subject and the scene was so dark I dialed down my FEC by almost 2 stops.

IMAGE 32

SELF-PORTRAIT: PAINTING WITH LIGHT

LOCATION: A dark alley
EQUIPMENT: One SB-900, Nikon D700, tripod
CAMERA SETTINGS: f/22, 30 seconds, ISO 200
FLASH SETTINGS: $\frac{1}{32}$ manual power

Sometimes, late at night, I have a creative urge to go out and create a photograph. It's not always easy to find a model late at night, so this project became a self-portrait.

Painting with light is a process in which the camera is placed on a tripod and the shutter is left open for a long exposure. The flash is then manually triggered multiple times by pressing the test button. This allows you to use flash in multiple places and directions with a single Speedlight.

The important thing to remember is to never get in between the flash's light and the camera; otherwise you will be exposed into the frame. If you are always behind the light and you keep moving, you won't be seen in the photograph. For this photograph, I fired my flash eight times, six on the background and two on myself. It took me several tries to perfect this shot. The biggest revelation was that I had to make sure to direct some flash onto my legs—otherwise I just looked like a floating torso in the scene.

This is a great way to creatively light a photograph with very little equipment.

IMAGE 33

CONCLUSION

I f I've learned nothing else from my journey through flash photography, it's that you just need to try things out. Get out there and practice—learn how to do everything, use your Nikon Speedlights, and play with the different modifiers (or even make your own). Once you learn the rules and techniques, you'll be ready to explore and see how you can use them creatively. When you master the power of what Nikon Speedlights and CLS have to offer, the only limit will be your imagination.

RESOURCES

EQUIPMENT

Nikon USA—www.nikonusa.com

Honl—www.honlphoto.com

Lastolite—www.lastolite.com

Strobies—www.interfitphotographics.com

Orbis—www.orbisflash.com

PocketWizard—www.pocketwizard.com

RadioPoppers—www.radiopopper.com

Westcott—www.fjwestcott.com/

PHOTOGRAPHERS

Chuck Arlund—www.chuckarlund.com

John Michael Cooper—www.altf.com

Tony Corbell—www.corbellproductions.com

Jerry Ghionis—www.jerryghionis.com

David Hobby—www.strobist.blogspot.com

Cliff Mautner—www.cmphotography.com/blog

Neil van Niekerk—www.neilvn.com/tangents

David A. Williams—www.davidanthonywilliams.com

After Dark Education—www.afterdarkedu.com

INDEX

UNLEASHING THE RAW POWER OF
Adobe® Camera Raw®

Mark Chen teaches you how to perfect your files for unprecedented results. *$34.95 list, 8.5x11, 128p, 100 color images, 100 screen shots, index, order no. 1925.*

BRETT FLORENS' ## Guide to Photographing Weddings

Learn the artistic and business strategies Florens uses to remain at the top of his field. *$34.95 list, 8.5x11, 128p, 250 color images, index, order no. 1926.*

500 Poses for Photographing Brides

Michelle Perkins showcases an array of head-and-shoulders, three-quarter, full-length, and seated and standing poses. *$34.95 list, 8.5x11, 128p, 500 color images, index, order no. 1909.*

Understanding and Controlling Strobe Lighting

John Siskin shows you how to use and modify a single strobe, balance lights, perfect exposure, and more. *$34.95 list, 8.5x11, 128p, 150 color images, 20 diagrams, index, order no. 1927.*

JEFF SMITH'S
Studio Flash Photography

This common-sense approach to strobe lighting shows photographers how to tailor their setups to each individual subject. *$34.95 list, 8.5x11, 128p, 150 color images, index, order no. 1928.*

Just One Flash

Rod and Robin Deutschmann show you how to get back to the basics and create striking photos with just one flash. *$34.95 list, 8.5x11, 128p, 180 color images, 30 diagrams, index, order no. 1929.*

WES KRONINGER'S
Lighting Design Techniques
FOR DIGITAL PHOTOGRAPHERS

Create setups that blur the lines between fashion, editorial, and classic portraits. *$34.95 list, 8.5x11, 128p, 80 color images, 60 diagrams, index, order no. 1930.*

DOUG BOX'S
Flash Photography

Master the use of flash to create perfect portrait, wedding, and event shots anywhere. *$34.95 list, 8.5x11, 128p, 345 color images, index, order no. 1931.*

Wedding Photographer's Handbook, 2nd Ed.

Bill Hurter teaches you how to exceed your clients' expectations before, during, and after the wedding. *$34.95 list, 8.5x11, 128p, 150 color images, index, order no. 1932.*

500 Poses for Photographing Men

Michelle Perkins showcases an array of head-and-shoulders, three-quarter, full-length, and seated and standing poses. *$34.95 list, 8.5x11, 128p, 500 color images, order no. 1934.*

Off-Camera Flash
TECHNIQUES FOR DIGITAL PHOTOGRAPHERS

Neil van Niekerk shows you how to set your camera, choose the right settings, and position your flash for exceptional results. *$34.95 list, 8.5x11, 128p, 235 color images, index, order no. 1935.*

Wedding Photojournalism
THE BUSINESS OF AESTHETICS

Paul D. Van Hoy II shows you how to create strong images, implement smart business and marketing practices, and more. *$34.95 list, 8.5x11, 128p, 230 color images, index, order no. 1939.*

THE DIGITAL PHOTOGRAPHER'S GUIDE TO
Natural-Light Family Portraits

Jennifer George teaches you how to use natural light and meaningful locations to create cherished portraits and bigger sales. *$34.95 list, 8.5x11, 128p, 180 color images, index, order no. 1937.*

Posing for Portrait Photography

Jeff Smith shows you how to correct common figure flaws and create natural-looking poses. *$34.95 list, 8.5x11, 128p, 200 color images, index, order no. 1944.*

FLASH TECHNIQUES FOR
Macro and Close-up Photography

Rod and Robin Deutschmann teach you to create beautifully lit images that transcend our daily vision of the world. *$34.95 list, 8.5x11, 128p, 300 color images, index, order no. 1938.*

The Portrait Photographer's Guide to Posing, 2nd Ed.

Bill Hurter calls upon industry pros who show you the posing techniques that have taken them to the top. $34.95 list, 8.5x11, 128p, 250 color images, 5 diagrams, index, order no. 1949.

BILL HURTER'S
Small Flash Photography

Learn to select and place small flash units, choose proper flash settings and communication, and more. *$34.95 list, 8.5x11, 128p, 180 color photos and diagrams, index, order no. 1936.*

Lighting Essentials

Don Giannatti's subject-centric approach to lighting will teach you how to make confident lighting choices and execute images that match your creative vision. *$34.95 list, 8.5x11, 128p, 240 color images, index, order no. 1947.*

Studio Lighting Anywhere

Joe Farace teaches you how to overcome lighting challenges and ensure beautiful results on location and in small spaces. *$34.95 list, 8.5x11, 128p, 200 color photos and diagrams, index, order no. 1940.*

The Art of Off-Camera Flash Photography

Lou Jacobs Jr. provides a look at the lighting strategies of ten portrait and commercial lighting pros. *$34.95 list, 8.5x11, 128p, 180 color images, 30 diagrams, index, order no. 2008.*

Family Photography

Christie Mumm shows you how to build a business based on client relationships and capture life-cycle milestones, from births, to senior portraits, to weddings. *$34.95 list, 8.5x11, 128p, 220 color images, index, order no. 1941.*

Boutique Baby Photography

Create the ultimate portrait experience—from start to finish—for your higher-end baby and maternity portrait clients and watch your profits grow. *$34.95 list, 7.5x10, 160p, 200 color images, index, order no. 1952.*

Flash and Ambient Lighting

FOR DIGITAL WEDDING PHOTOGRAPHY

Mark Chen shows you how to master the use of flash and ambient lighting for outstanding wedding images. *$34.95 list, 8.5x11, 128p, 200 color photos and diagrams, index, order no. 1942.*

Behind the Shutter

Salvatore Cincatta shares the business and marketing information you need to build a thriving wedding photography business. *$34.95 list, 7.5x10, 160p, 230 color images, index, order no. 1953.*

500 Poses for Photographing Couples

Michelle Perkins showcases poses that will give you the creative boost you need to create an evocative, meaningful portrait. *$34.95 list, 8.5x11, 128p, 500 color images, order no. 1943.*

Master's Guide to Off-Camera Flash

Barry Staver presents basic principals of good lighting and shows you how to apply them with flash, both on and off the camera. $34.95 list, 7.5x10, 160p, 190 color images, index, order no. 1950.